IMAGES
of America

LAGUNA NIGUEL

IMAGES
of America

LAGUNA NIGUEL

Ted Wells

ARCADIA
PUBLISHING

Published by Arcadia Publishing
Charleston, South Carolina

Printed in the United States of America

Library of Congress Control Number: 2016957579

For all general information, please contact Arcadia Publishing:
Telephone 843-853-2070
Fax 843-853-0044
E-mail sales@arcadiapublishing.com
For customer service and orders:
Toll-Free 1-888-313-2665

Visit us on the Internet at www.arcadiapublishing.com

CONTENTS

ACKNOWLEDGMENTS

Photographers hired by Cabot, Cabot & Forbes, Laguna Niguel Corporation, and publishers throughout the history of the community include Ansel Adams, Don Bush, Kelly's Industrial Photography, Larry Harmon, John Hartley, Laguna Beach Photography, Bill Laird, Leland Y. Lee, Tom Leonard, Lloyd de Mers Air Views, Fred Lyon, Pacific Air Industries Aerial Photography, Marvin Rand, David Ross Commercial/Industrial Photography, Charles Schneider Photography, Ezra Stoller, Studio One Commercial Photography, Vorhees-Trindle & Nelson Inc., and Todd Walker.

The images and information in this volume appear courtesy of the Orange County Archive's (OCA) Alfred B. Osterhues Collection, Robert R. Hosmer Collection, and Wayne Curl Collection; Dana Point Historical Society (DPHS); Dee Wells Collection (DWC); Knowlton Fernald, American Institute of Architects (AIA) Archives (KFA); Laurence R. Lizotte Archives (LLA); Laguna Niguel Family YMCA (Laguna Niguel YMCA), Laguna Niguel Historical Society; Mary Ellen Christenson Collection (MECC); Mission Lutheran Church archives (MLCA); Ricardo A. Nicol, AIA Archives (RNA); and Victor Gruen Associates Archives (VGA).

Special thanks go to Pat Bates, Bruce Rasner, Carl Schulkin, Solveig Darner, and Sheryl Bailen of the Laguna Niguel Historical Society; Mary Crowl and Barbara Force Johannes of the Dana Point Historical Society; Elaine Gennawey; John Mark Jennings; Jerry Slusiewicz; Kelly Jennings; Sean McCracken; Tom Stewart; Mary Ellen Christenson; Linda Bayme; Kaz Kishimoto; Ricardo Nicol; Janie Fernald; David Fernald; Bob Bunyan; Larry Lizotte; Alan Hess; Kelly Sutherlin McLeod; Mike Prelip; Carlos Rueda; Bradley Kaye; and Dee Wells.

INTRODUCTION

Laguna Niguel is one of America's earliest master-planned communities. Cabot, Cabot & Forbes of Boston acquired the historic ranch lands beginning in 1958 and established Laguna Niguel Corporation as the developer of the community through investments on the Pacific Coast Stock Exchange in 1959. The international architect Victor Gruen, at his office in Los Angeles, was the master planner of the 7,000-acre-plus site. Noted architects, landscape architects, engineers, and artists were part of the team that created the site planning, residences, commercial and retail centers, recreational facilities, golf courses, parks, open spaces, and more than 80 miles of scenic hiking, bicycle, and equestrian trails for what the developers called "California's Most Remarkable New Town."

Laguna Niguel Corporation required that the ranch development plan recognize the natural assets of Southern California and harmonize with the physical features of the terrain. A goal was also that what they referred to as the "New City" was to be "an outstanding contribution to the coastal area both during its growth and when fully developed." To achieve that goal, the basic planning criteria outlined in Gruen's documents included preserving the natural beauty and environment of the ranch by considering topography as a major governing factor in arriving at a land use plan, thereby minimizing earth moving; beautifying the ranch by means of an "enforced" landscaping program; providing a full range of recreational activities; and ensuring Laguna Niguel Corporation always maintained positive control over the ranch development through building restrictions and an orderly stage development plan.

Professional consultants were brought onto the team to produce economic surveys, market analyses, geologic studies, population projections, traffic studies, oceanographic studies, feasibility reports, and preliminary engineering studies related to water systems, sewage disposal systems, underground television cabling, grading and landscaping solutions, hillside construction techniques, shopping center locations, school locations, industrial park locations, golf course locations and configurations, club management and structure, park locations, and the legal structure of the communities.

As written by the director of planning and architecture for Laguna Niguel Corporation, Knowlton Fernald Jr., AIA,

> The cooperation, analysis, and contribution of all of the professional consultants and governmental departments is integral to the production of a plan which is to guide development from virgin land to a mature community. The governmental groups will all take an active part in controlling this evolution, and therefore their guidance in the planning phase is necessary to set the stage for orderly growth.
>
> Intensive study of this magnitude is most important in building a beautiful and stimulating environment based on sound economic principles and at the same time avoiding problems inherent in many existing communities because they have just grown without the advantage of pre-planning.

For the topography and boundary survey work, aerial surveys of the entire ranch were started in early 1959. Economic reports started that same year. Cabot, Cabot & Forbes had hired consultants for economic studies related to land use requirements, market potential of varied priced properties, absorption rate of developed land, and percent return on investment. Stanford Research Institute had recently completed a survey of Orange County economics at that time, and those documents were to assist with overall visions for planning within the area.

At the start of the Laguna Niguel plans, there was no master plan for the southern portion of Orange County. Because of the recent sales of the Shumaker, Moulton, Reeves, and Whiting ranches, the county saw an urgent need for a master plan of the major land uses in that area. As on the original Gruen master plan map, the area that eventually became the houses at Monarch Bay was not included in the county's master plan in early 1959. A developer, George A. Gade, was trying to obtain a "Mobile Homes Park" variance on the Moulton beachfront property south of Coast Highway, between Three Arch Bay and the Laguna Niguel property. Gade had made no formal application yet with the county for that development. The residents of Three Arch Bay strongly opposed the mobile home project, and Laguna Niguel Corporation was also not supportive of that project. Eventually, Cabot, Cabot & Forbes approached Gade and entered into a lease agreement on that portion of the Moulton Ranch property, allowing the Moultons to lease that property to individual residents as part of Laguna Niguel Corporation's development so that site could become Monarch Bay. This specific site changed and expanded the oceanfront boundaries of Laguna Niguel and helped expand the earliest residential community within the overall development. This neighborhood was planned with a layout character similar to Three Arch Bay, the private community directly to the north, by building single-family houses on private streets. The entry, at the southern end of Crown Valley Parkway at Coast Highway, was originally planned as gate guarded, primarily to limit public access to the beach.

For development of the Laguna Niguel site, many residents in Three Arch Bay and South Laguna were very pleased to see the development of that valley. They wanted to see a road connection through the ranch that generally followed what was identified at the time as Arroyo Salada and Sulphur Creek. This would provide a connection between Coast Highway and the San Diego Freeway. Victor Gruen Associates estimated anticipated traffic volumes when the ranch was fully developed. This led to possible major road alignments throughout the community and anticipated traffic volumes that would affect road widths, landscaping, sound control, and housing. As written in the early planning documents for the community, "Every community, as it matures, finds automobile traffic an increasing problem. At Laguna Niguel, every effort has been made to provide for good movement of through traffic and access *to* any community in the development without allowing through or fast traffic *within* any community."

The developer also established agreements with the Los Angeles Municipal Water District and other water districts in Orange County to help create major water lines and reservoirs in a private water district within the community that could be expanded as the development grew. Electric power lines were installed underground. The developer also created one of America's first underground cable television systems; no television antennas were allowed in the community. All of the utility infrastructure systems were organized through Laguna Niguel Corporation. The major utility work began in 1959 and continued as the community expanded through the 1980s.

The geology of Laguna Niguel is an interesting aspect of the community. The valley and canyon terrain were originally underwater millions of years earlier. The highest peak in Laguna Niguel, 936-foot Niguel Hill, was an island in the ocean. A community park and paths exist at that site, which has a sandy, beach-like terrain, now with full ocean views from Palos Verdes to San Diego and 360-degree views toward Orange and Los Angeles Counties. The consulting geologist completed his preliminary report on June 1, 1959, describing the general geology of the ranch. His report and map indicated possible well locations, identified geologic soils, and specified certain areas within the ranch that would require careful engineering work when grading took place. Also within Laguna Niguel is a very large and rare collection of rocks, San Onofre Breccia. The distinctive features of this rock are the composition and color, which varies greatly from

red-brown to blue-gray, with mixed conglomerate beds of the stone. The geologic formations in Laguna Niguel contain large primordial skeletons and small forms of fossilized sea life along with pebbly chips and quartz-like cobble intermingled within the solid rock in massive coarse-grained sandstone beds mixed with extremely large boulders.

Gruen's analysis of the climate in the ranch determined that it is characteristic of the Pacific Coast region: wet and cool in the winter, dry and warm in the summer. The climate along the coast and within the central valley area is influenced by the cool, moist ocean breezes and relatively high humidity that lessen evaporation and transpiration, in contrast to the hot, dry atmosphere of the interior valleys. The direct influence of fog during the summer months extends inland through Laguna Niguel more than a mile and affects the landscape of the area. The rainy season usually begins in late October and continues until early April. Often the winds come into Laguna Niguel from the southwest, sometimes the northwest, and can change paths and speeds because of the very steep slopes and deep valleys.

A question posed by Gruen related to the landscape was this: "At this point we have to ask, why are there no trees? Why is this good grassland?" This is, of course, a surprising question for many people today, especially because now there are hundreds of thousands of trees throughout Laguna Niguel. The soils in the ranch areas that provided the best grazing were those well supplied with organic matter. Those areas had a high water-holding capacity due to the clay in the soil and did not become packed after trampling by the sheep that once grazed here. The area consists mostly of diablo clay adobe, with about 10 inches of surface soil overlaying the heavier-textured clay. Some surface areas within the valley are covered with light sandy materials up to 15 inches deep over a stratum of gypsum shale. Natural tree growth was an issue at that time because of the dense clay subsoil, since early tree growth is very limited without frequent watering and good drainage. The underlying clay areas are undulating, with an even surface of soil covering, which allowed water to stand in pockets after heavy rainfall, causing root and stem rot. During the summer, the clay soil tends to crack, which can break feeder roots and stunt tree growth. The soil of the flat terrace areas and the deepest stream areas of the valleys is mixed. These areas allowed a dense cover of natural vegetation, mainly due to the good drainage and steepness of the slopes. Beginning in 1959, the landscaping concept plans were created by landscape architect Morgan "Bill" Evans. Over the next decade, more than 100,000 trees were planted throughout the community in open areas and slopes. By the time the community was fully developed, more than 300,000 large trees were planted.

Gruen's master plan positioned 11 churches on sites varying between three and six acres. Four of the church sites were placed in low areas of the valley, usually with views of lakes, and he placed seven church sites on the slopes and hilltops with views facing north, south, east, and west. The concept of the site locations was that each church within the community had a unique view of the valleys, the mountains, and the ocean at sunrise and sunset.

Two golf courses were planned, one private and one public. David W. Kent, a golf course designer, was hired in coordination with Gruen. By mid-1959, Kent had already submitted a preliminary routing plan for the private course. Eventually, what was planned as the public course location became a private course, El Niguel Country Club. The second course was planned further inland, along the current location of Alicia Parkway, but in the 1980s, the secondary public course was designed closer to the coast, with some greens at the beach, directly southeast of Monarch Bay.

Two six-acre hotel sites were proposed along Coast Highway, one adjacent to Monarch Bay and the other on the bluff that is now the site of Ritz-Carlton Laguna Niguel, at Salt Creek Beach, south of Monarch Bay. In the original designs by Gruen, between 120 and 200 hotel rooms were planned, with six-acre sites being the minimum size. Access to the beach from the hotels was by pedestrian paths or by driving down the slope. At the same time, the proposed shopping center on the inland side of Coast Highway, now Monarch Bay Plaza, was part of the earliest master plan. This 36-acre site was planned to accommodate about 200,000 square feet of retail area in the main building complex on the eastern portion of the site. Additional commercial buildings, such as a gas station and automotive service, were to be constructed in the narrow portion of the

property west of the shopping center. Additional business offices for Laguna Niguel Corporation and medical offices were planned for the western parcel. The main sales and information center was planned at the corner of Coast Highway and Crown Valley Parkway; this was the earliest sales center for the community. The early staff and architectural offices were housed in the ranch horse stable buildings at the current south boundary of Laguna Niguel.

The residential area of Niguel Terrace, designed for the northwest corner of Coast Highway and Crown Valley Parkway, was originally 62 developable acres for 220 building sites. The streets were designed as single-loaded, as was the case for all of the original sloped neighborhoods throughout Laguna Niguel, so that there would never be any view obstructions. From the start, all neighborhood planning by Gruen's office was to create interesting neighborhoods, where privacy and linked community were the key goals.

Crown Valley Parkway, a seven-and-a-half-mile limited-access scenic highway through the central part of the coastal valley, forms the arterial path through the community from Pacific Coast Highway to the San Diego Freeway. Gruen's June 4, 1959, "Criteria for Plan of Major Elements" in Laguna Niguel recommended that the town center be located at a point "most convenient to the entire ranch population in terms of distance and access." This location, at Crown Valley and Alicia Parkways and Niguel Road, was to include retail, offices, a cultural center, a theater, and housing. Gruen believed that, with all factors considered, the town center, as proposed by the master plan, was perfectly located to serve Laguna Niguel. "The grouping of these elements," said Gruen, "produces a highly productive urban complex, with each element complementing the other and combining to achieve financial success and community acceptance."

Main streets throughout the community interconnect while following the natural contours of the terrain. The streets were designed with central landscaping medians and buffered areas of landscape, nearly always adjacent to steep slopes filled with shrubs and trees. The slope areas also allowed for interconnected natural landscape for native wildlife in the hills and canyons.

Within the original neighborhoods designed in Laguna Niguel, greenbelt areas were designed for safer walks to schools, extensive community parks, hilltops, and the coastline. These paths were to provide safer walks for families, hikers, and bicyclists so that roadside walks and travel could be avoided.

As referenced in the master plan, Fernald warned that if land is not reserved within a community for a school, by the time there is sufficient population to justify construction of the school, the land may have been put to another use. The school might then have to be located outside of the area it serves, and children would need to be transported a greater distance by bus. In Laguna Niguel, the school sites were originally set aside permanently for that use only and were designed at the optimum location to serve every neighborhood. In many cases, bus transportation could be eliminated entirely in the community, and as the planners noted, the social life of the children is greatly enhanced.

The master plan documents and reports for Laguna Niguel not only show the complete designs of the community but also clearly state how people and a community should interrelate. They also provide warnings about how communities can stumble.

A good master plan and careful daily implementation of the plan were two of the primary tools of everyone involved with Laguna Niguel Corporation. Their goal was to transform, and maintain, the beautiful rolling hills into an environment in which residents could live, work, and play. The beauty seen by the planners, architects, and landscape architects took time to achieve. And as Fernald wrote, "In time, the dream of good design and careful planning will be manifest."

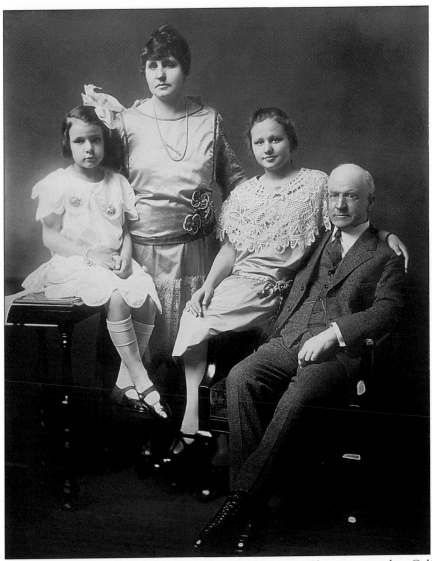

MOULTON FAMILY. Lewis Fenno Moulton (1854–1938), born in Chicago, moved to California in 1874. He tended sheep for Charles French and soon bought the business, renting land from Wilmington to Oceanside. By 1884, he was renting Rancho Niguel from Cyrus B. Rawson, and in 1895, Moulton and his business partner, Jean Pierre Daguerre, purchased the land, establishing the Moulton-Daguerre Ranch. Moulton's uncle in Boston provided financial support, and the partnership acquired additional ranch lands. In 1911, Daguerre died when his carriage overturned; the horses had been scared by a passing automobile. The families then reduced the sheep business and expanded their cattle ranching. Lewis died in 1938. His wife, Nellie Gail, then 59, managed the ranch lands until 1950. The Moulton daughters and the Daguerre daughters handled the business until the Daguerres decided to step out of ranching, so the land was divided: over 14,000 acres to the Moultons and over 7,000 acres to the Daguerres. Daughters Charlotte and Louise Moulton divided the land between themselves. Nellie Gail, who was an artist and philanthropist, held onto some of the original land. Pictured from left to right are the Moulton family: daughter Louise (born 1914); wife Nellie Gail (born 1879); daughter Charlotte (born 1910); and Moulton. (Moulton Family Foundation.)

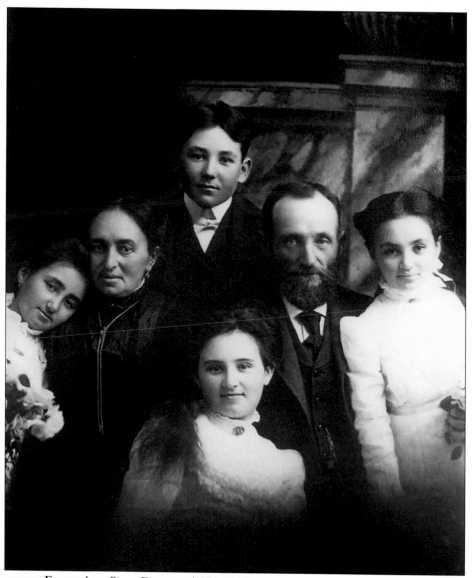

DAGUERRE FAMILY. Jean Pierre Daguerre (1856–1911) came to Los Angeles in 1874 from Hasparren, France, in the southwestern Pyrénées-Atlantique French Basque region. He made the trip with Amestoy family members and Maria Eugenia Duguet, who were moving to Los Angeles. Daguerre began working on the Domingo Amestoy ranch, one of the largest wool producers in Southern California. Amestoy was one of the founders providing financing in 1871 for Farmers and Merchants Bank in Los Angeles. Three of the founders of the bank later founded the University of Southern California. In 1882, Daguerre partnered with Marco Forster in San Juan Capistrano. On October 7, 1886, Daguerre married Maria Eugenia. In 1895, Daguerre left the Forster ranch and formed a partnership with Lewis Moulton: Daguerre bought one third of Rancho Niguel, and Moulton bought two thirds. On June 3, 1954, the Daguerre daughters' one-third portion of the 21,732-acre Moulton Ranch was deeded to Eugene Shumaker; this would become the 7,108 acres for Laguna Niguel. From left to right are daughter Josephine (born 1892), wife Maria Eugenia, son Domingo (born 1887), daughter Juanita (born 1888), Daguerre, and daughter Grace (born 1890). (OCA.)

One

Discovering the Rancho and the First Master Plans

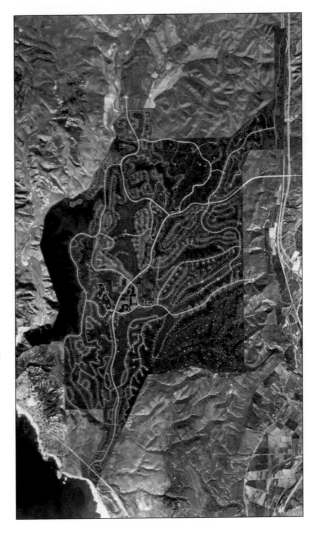

Master Plan, 1959. The master plan for Laguna Niguel was the work of Victor Gruen, an international architect in design and development planning. This 1959 drawing, originally overlaid on an aerial photograph of the 7,000-acre-plus site map, was by Gruen's Los Angeles–based office. Laguna Niguel, along the coast in southern Orange County, is 48 miles south of downtown Los Angeles and 55 miles north of San Diego. (KFA.)

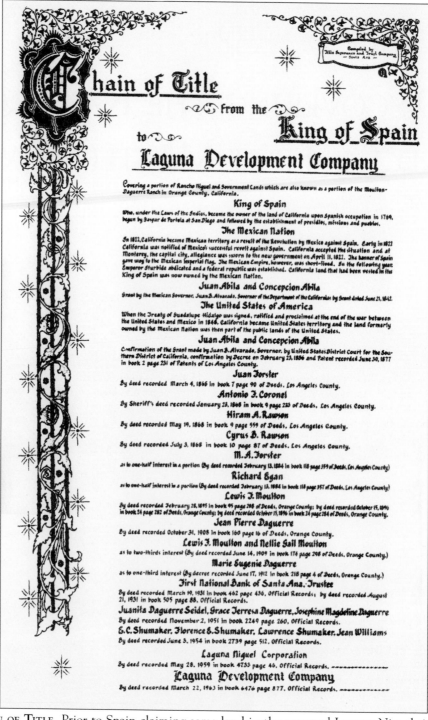

CHAIN OF TITLE. Prior to Spain claiming some land in the eventual Laguna Niguel site, the earlier residents along the coastlands in the region for over 10,000 years were the Acjachemen, indigenous people of California, also later known as Juaneños. They had many villages, including Niguili, near the Aliso and Sulphur Creeks. (KFA.)

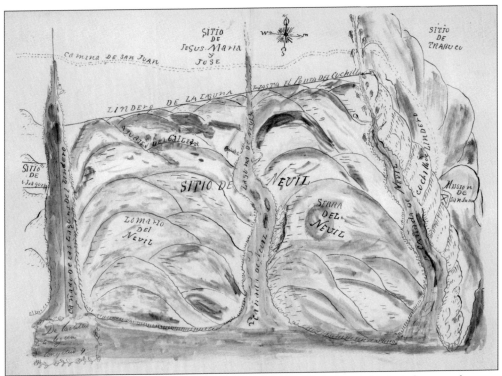

SITIO DE NEUIL, MAP OF RANCHO EL NIGUEL, C. 1840S. This pen-and-ink and watercolor map with conceptual shapes by William P. Money shows the creeks and lakes within the property, the steep hillsides, adjoining ranchos, and the location of Mission San Juan Capistrano southeast of the rancho. Juan Avila was the ranchero owner beginning June 21, 1842. (Huntington Library, San Marino, California, Solano-Reeve Collection.)

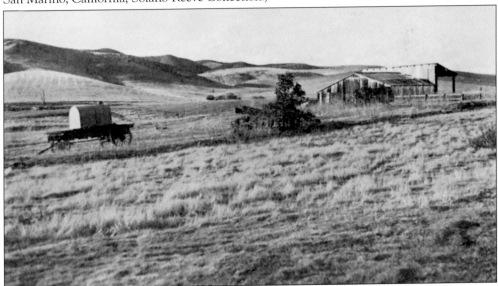

RANCHO NIGUEL RANCH AND FARMLAND. French Basque sheepherding was an important part of the rancho's activities on the hillsides in the narrow valleys and canyons. In the flatter areas of the northern rancho property, the wider fields were also used for cattle ranching. (OCA.)

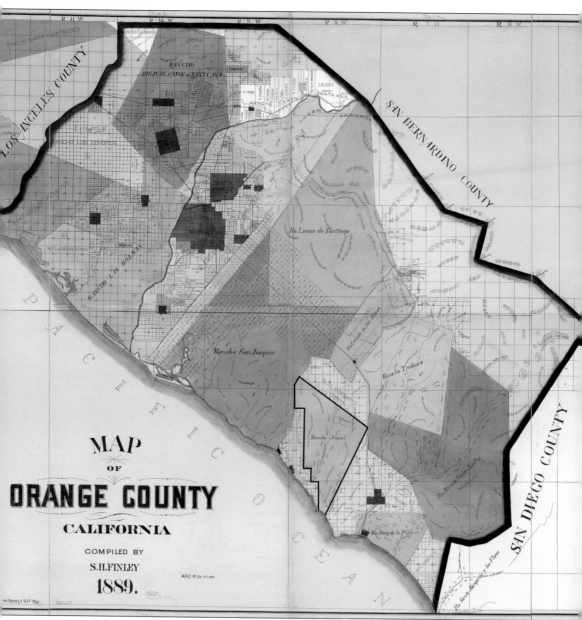

Map of Orange County, Rancho Niguel, 1889. The County of Orange was officially formed, separating from Los Angeles County, on August 1, 1889. This map by S.H. Finley was made the same year, showing the existing rancho borders throughout the new county, including Rancho Niguel. Seventy years later, more than 7,000 acres of the southeast portion of the rancho would become Laguna Niguel. (OCA.)

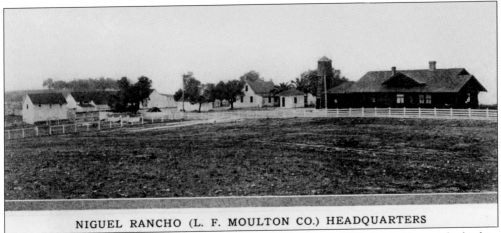

NIGUEL RANCHO (L. F. MOULTON CO.) HEADQUARTERS

NIGUEL RANCHO, L.F. MOULTON COMPANY HEADQUARTERS, 1913. Beginning with the late 1890s acquisition of Rancho Niguel by Moulton and Daguerre, the families lived in houses at this location in the very northern area of the rancho. Later, the Daguerre daughters acquired the southern third of the rancho; Moulton had the northern two thirds. This headquarters site would later be within Laguna Hills. (OCA.)

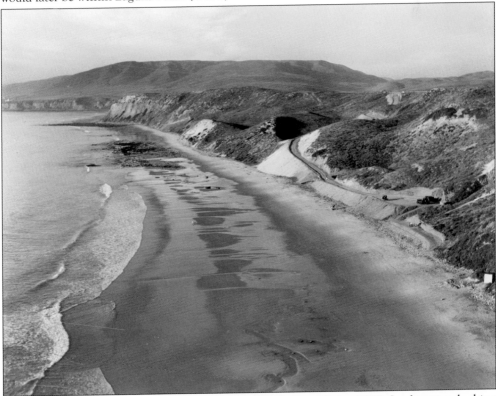

VIEW TO RANCHO NIGUEL FROM DANA POINT HEADLANDS, JUNE 1928. In this view looking north, the Rancho Niguel and Moulton properties extend to the coastline, on the far left, along Salt Creek Beach. The slope from the bluff to the center hilltop area and, to the far right, along the horizon is all Rancho Niguel. Later, the bluff point at the left and the coastline property south to the graded road would be part of Laguna Niguel. (OCA.)

17

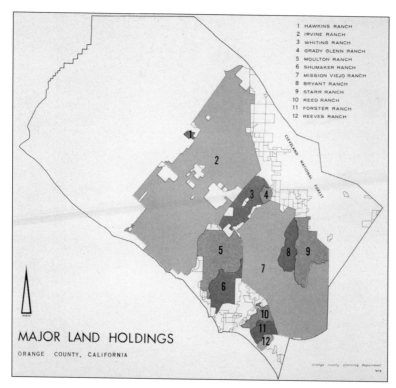

MAJOR LAND HOLDINGS

ORANGE COUNTY, CALIFORNIA

MAJOR ORANGE COUNTY LAND HOLDINGS, EARLY 1959. The largest private land holdings in Orange County included the 7,000-acre-plus Eugene Shumaker Ranch. Until 1954, that parcel was owned by the Daguerre daughters and had been part of the Moulton-Daguerre Ranch. Shumaker sold the property to Cabot, Cabot & Forbes after initial sales discussions started in 1958. (KFA and DPHS.)

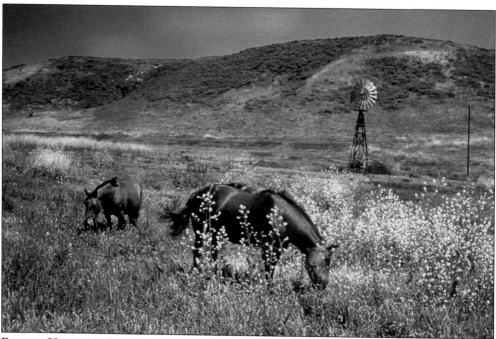

RANCHO HORSES, 1959. Noted photographers were hired by Laguna Niguel Corporation, including Ansel Adams, Marvin Rand, Ezra Stoller, and many others who visited the rancho, photographing the entire site within the valley and canyons, climbing to hilltops, and capturing aerial images from an airplane. Ranchers and photographers rode horses throughout the site. (RNA.)

18

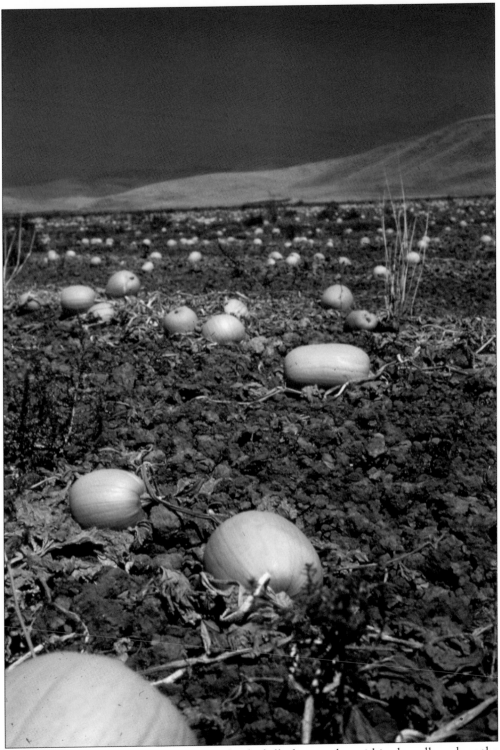

PUMPKIN PATCH, 1959. Sheep grazing was for the hillside areas, but within the valley, where the soil was fertile with better water access, small areas of seasonal crops were grown. (RNA.)

SHEEP HERDING, 1959. Larger areas of level, open terrain are found in the northwest area of the ranch. The hillsides were used for sheep; the lower areas were often the cattle grazing fields. (OCA.)

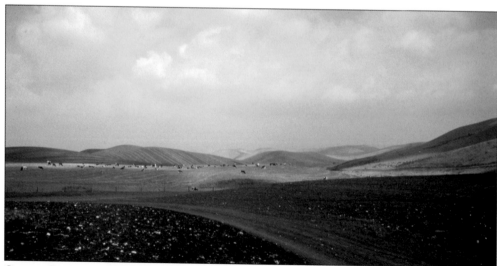

CATTLE GRAZING, 1959. The Moulton family had restocked much of the northwest ranch lands within the Laguna Niguel boundaries with cattle. One reason for this was that rapid development in Los Angeles and north Orange County had made it difficult to transport the sheep flocks to distant pasturage. (OCA.)

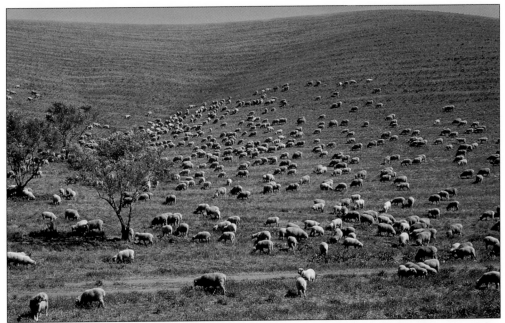

MERINO SHEEP GRAZING, 1959. French Basque ranchers had merino sheep on the site of this hillside nine months each year. (RNA.)

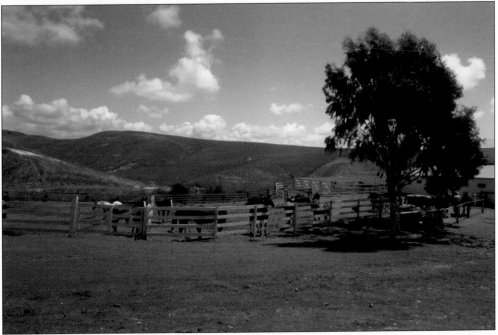

NIGUEL RANCH HEADQUARTERS, 1959. At the southern end of the rancho were a large horse stable, corrals, stalls, and a farmhouse—which later became the Niguel Ranch headquarters—that had been at the site for nearly 80 years. Though management work by Cabot, Cabot & Forbes for the planned development had begun in 1958 at other office locations outside of the ranch, architecture and office staff work began at this site within the ranch structures in the fall of 1959. (KFA and DPHS.)

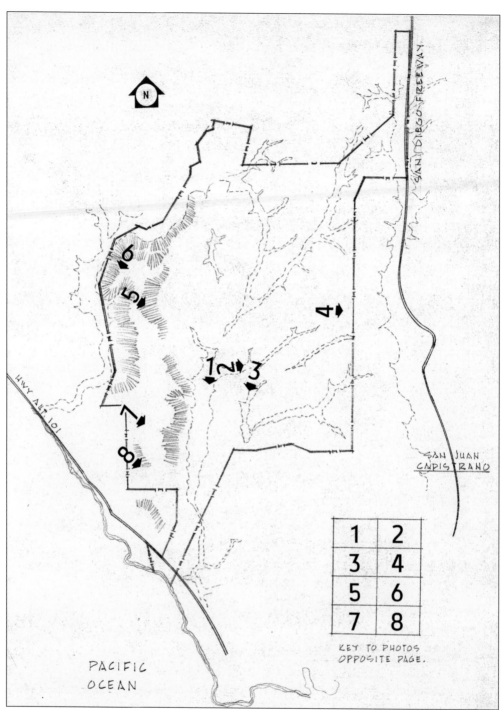

MAP IDENTIFYING PHOTOGRAPHS OF THE SITE, 1959. This map and the images on the opposite page were included in Victor Gruen Associates' "Background Data and Site Info for Laguna Niguel Development" report of June 19, 1959, which contained "all the background data and basic site information assembled to date in connection with the Laguna Niguel project." (KFA and VGA.)

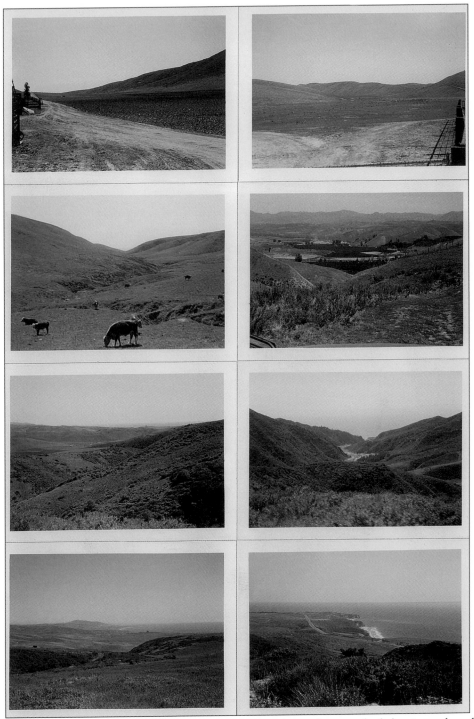

PHOTOGRAPHS OF THE SITE, 1959. Victor Gruen Associates photographed the site and used a number of these photographs to help with the planning studies. Eight of the images were included in the early report, keyed to the map on the opposite page, to show the general physical features of the site as well as ocean, valley, and mountain views from the site. (KFA and VGA.)

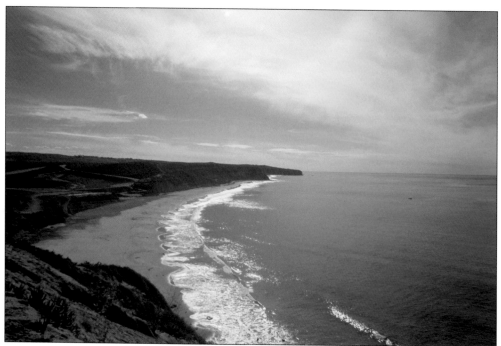

SALT CREEK AND ARROYO SALADA COASTLINE, 1959. This view looking southeast from the future site of Monarch Bay houses is of Salt Creek Beach, acquired by Laguna Niguel Corporation, as stated in the June 19, 1959, progress report by Paine, Weber, Jackson & Curtis to underwriters and stock dealers. This statement noted that this coastline was to be developed to provide surfing and swimming areas for all of the future residents of Laguna Niguel. (KFA and DPHS.)

MOULTON BAYFRONT BLUFF, 1959. This portion of the oceanfront property was not yet part of the Laguna Niguel development. Discussions were taking place, and a 60-year master lease on this bluff-top Monarch Bay property was entered into between Laguna Niguel Corporation and the Moulton family in 1960. (RNA.)

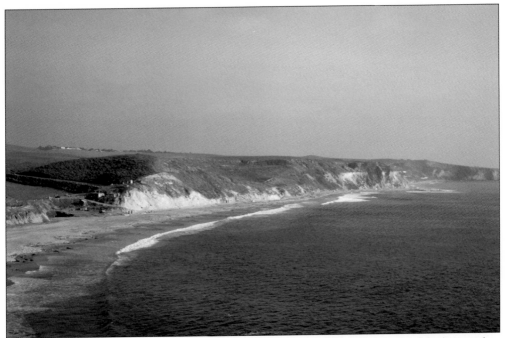

BEACHFRONT SHACKS AT SALT CREEK, 1959. Since the 1910s, this has been one of the best surfing spots in the area. In the late 1920s, larger beach camp houses were built, and some remained until 1961. (RNA.)

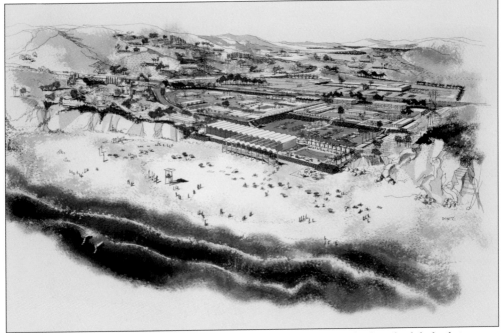

MONARCH BAY CLUB AND MOTELS, 1959. In their initial design, the beach club facilities were located on 1,000 feet of what was to be private oceanfront property. The beachfront complex was to include a motel and hotel. The first houses in Laguna Niguel were built to the left in this drawing by Carlos Diniz, on the bluff and the hillside. (KFA.)

RAILROAD ADJACENT TO THE RANCHO, 1959. This northeast location was originally planned to be the intersection of the Crown Valley Parkway and the freeway at what is now Avery Parkway. In 1960, the master plan changed in this area because access across this parcel was not yet obtained, and the Crown Valley Parkway interchange was moved to the north. (KFA and DPHS.)

NORTHEAST PARCEL, 1959. Looking north on the site adjacent to the highway and railroad, this area was master-planned as an industrial park. This site would also later become the access to the freeway when the plan relocated Crown Valley Parkway, passing between the center and distant hillsides. (KFA and DPHS.)

SAN JUAN LAKE, 1959. An existing pond, spring fed and about 20 feet deep, was located in the southeast portion of the ranch. The architects and developer proposed that it remain and be enlarged so that one-acre lots and a church site could abut the lake. (RNA.)

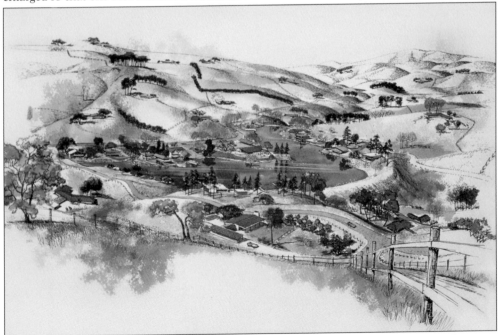

RESIDENCES AT SAN JUAN LAKE, 1959. Hundreds of choice waterfront and water-view lots were planned by enlarging the existing lake and adding another, even larger lake, which exists today. Many of the highest-priced houses were planned for the lakes, but the lots were sited without disturbing the existing land. This rendering is by Carlos Diniz. (KFA.)

SULPHUR CREEK, 1959. The second lake planned in the community, Laguna Niguel Lake, was later graded in this valley for the regional park in the northern portion of the ranch. A retention basin and dam were required so that a maximum-area lake could be constructed, since the ground slope in this part of the valley is less than in any other area in the ranch. (OCA.)

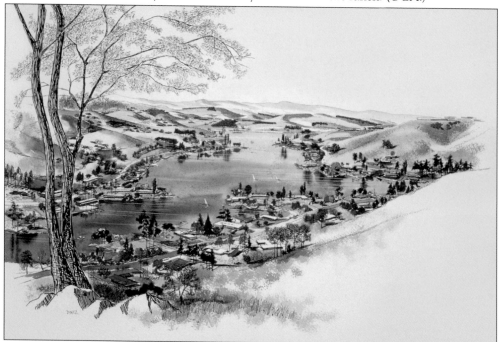

RESIDENCES AT LAGUNA NIGUEL LAKE, 1959. The houses proposed for Niguel Ranchos, estate lots of one or more acres with private horse stables on each parcel, would have views of Laguna Niguel Lake. This rendering is by Carlos Diniz. (KFA.)

BASQUE SHEEP HERDER, 1959. There were no paved roads within the 11-square-mile ranch lands, just paths used by the Basque ranchers. This image was taken looking west from what would later be the town center site; in the background is the proposed site for a high school. (RNA.)

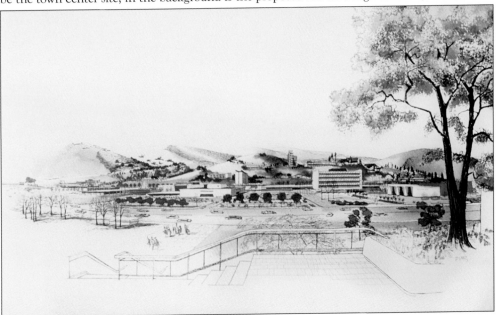

TOWN CENTER AND CIVIC CENTER, 1959. The original town center concept, located at Crown Valley Parkway and Alicia Parkway, combined commercial and civic uses such as a library, theater, governmental utility and general offices, banks, restaurants, medical services, a radio station, a newspaper office, a dance studio, community services, and adjacent higher-density housing. This rendering is by Carlos Diniz. (KFA.)

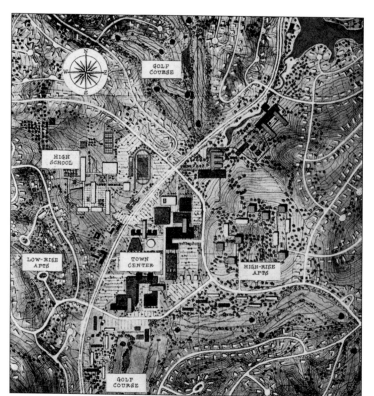

TOWN CENTER AREA MASTER PLAN, 1959. The purpose of the town center and two golf course location studies, as stated in the Gruen planning report, was to "give impetus to the recreational character" of the ranch, to bring people into the central portion of the ranch during the first stages of development to encourage a general public interest, and create desirable homesites in the interior of the ranch. (OCA, Alfred B. Osterhues Collection.)

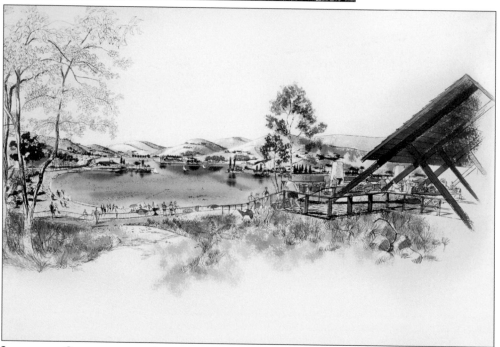

LAKEFRONT CLUBHOUSE AND RECREATION, 1959. A lakefront clubhouse and recreation area were to be at the southern shore of the lake at Sulphur Creek. This site is now the Laguna Niguel community park. This rendering is by Carlos Diniz. (KFA.)

HAY AND EQUIPMENT STORAGE, 1959. In the southern half of the narrow, central valley, a large storage structure served the sheepherders. Work on this portion of the valley would start in early 1960 for El Niguel Golf Course. (RNA.)

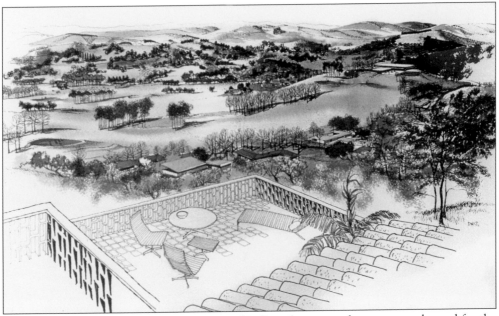

EL NIGUEL COUNTRY CLUB RESIDENCES, 1959. Sites for custom houses were planned for the northern area of the golf course, as rendered by Carlos Diniz. The modern architecture, with large glass walls facing the course and private solid walls and courtyards facing the winding streets, was part of the design requirements. (RNA.)

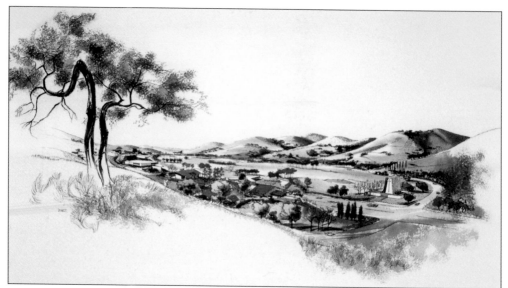

EL NIGUEL COUNTRY CLUB, SOUTH CONCEPT, 1959. Gruen's office prepared a study indicating all potential course locations on the ranch—the report noted at least 18 different locations. In planning the golf course, the developers determined the best location possible with respect to the topography and how much land would experience an increase in value by overlooking the course. This rendering is by Carlos Diniz. (OCA, Alfred B. Osterhues Collection.)

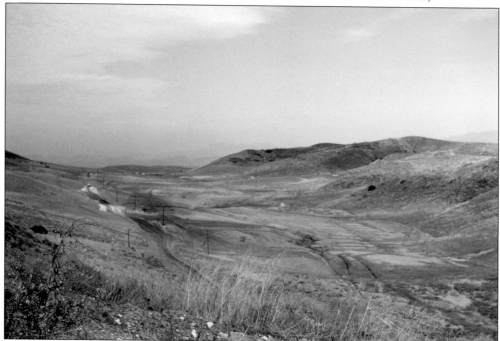

INFRASTRUCTURE WORK ON THE RANCH BEGINS, EARLY 1960. This view, from a hill west of the ranch headquarters, looks north into the valley, where Crown Valley Parkway and El Niguel Country Club would be located. Electric poles were installed to assist power supplies for installation of underground utilities and provide additional power at the southern end of the ranch. (KFA and DPHS.)

Two

THE MASTER-PLANNED COMMUNITY

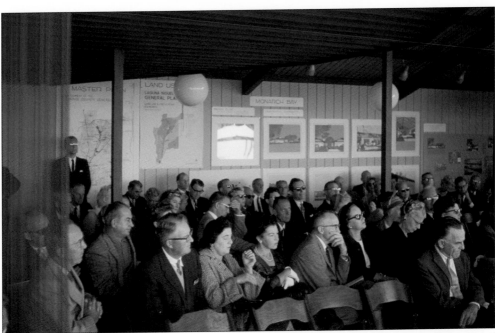

FIRST ONSITE ANNUAL STOCKHOLDERS MEETING. Initial financing for the project came in April 1959, when Laguna Niguel Corporation netted approximately $8.2 million through the sale of shares to over 7,000 stockholders on the Pacific Coast Stock Exchange. The next year, this investors meeting, in the new sales office at Crown Valley Parkway and Coast Highway, introduced the latest updates to the master plan and the newest neighborhoods in the community. (KFA.)

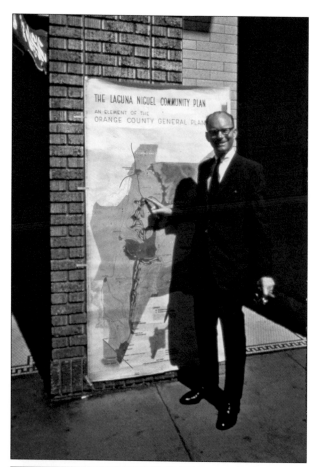

ENGINEERING AND PLANNING BEGINS, 1959. Al Osterhues displays the master plan after a meeting with the Orange County Planning Commission. Osterhues, chief engineer and planner for Laguna Niguel Corporation, was responsible for the engineering of the development. His civil engineering degree was from the University of Southern California. Osterhues supervised the earliest complex engineering studies needed for streets, neighborhoods, El Niguel Country Club, the 615-acre research park, three man-made lakes, and the 220-acre industrial park. (OCA.)

GRADING AND INFRASTRUCTURE WORK BEGINS, 1959. As part of the original master plan, more than 200 miles each of gas, water, and sewer lines would network the property. More than 100 miles each of electrical, telephone, and television lines would be installed underground. (RNA.)

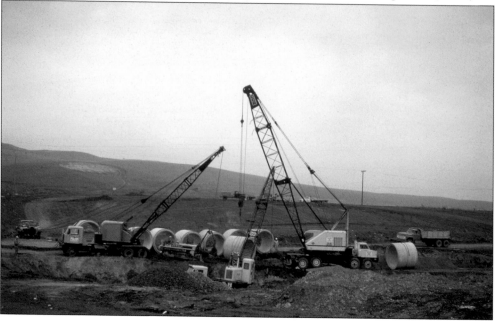

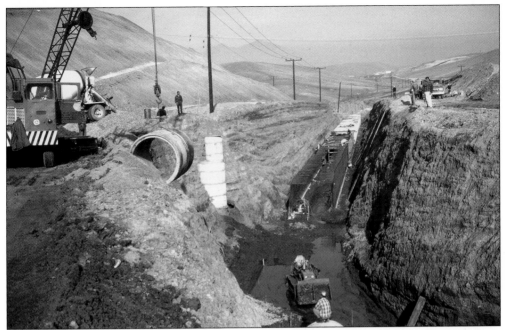

WATER SUPPLIES AND UNDERGROUND SYSTEMS, 1960. All of the original Laguna Niguel acreage was located within the Metropolitan Water District except for 136 acres that were part of the Coastal Water District, where water was immediately available to be connected in November 1959. The major infrastructure work then started in other parts of the rancho. (RNA.)

MAJOR EXCAVATION AND STRUCTURAL UTILITY SYSTEMS, 1960. Joint agreements with Los Angeles Metropolitan Water District and other water districts in Orange County resulted in a major water line to the community. Water supply lines increased beyond the planned 200 miles through the valley in mid-1962; at the end of 1965, thirty miles of additional water distribution lines had been built within the community. (RNA.)

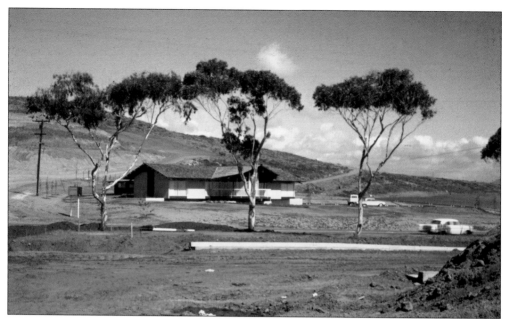

LAGUNA NIGUEL CORPORATION SALES OFFICE, 1960. At the northeast corner of Coast Highway and Crown Valley Parkway, the sales and staff office was the onsite headquarters for the corporate staff. (OCA.)

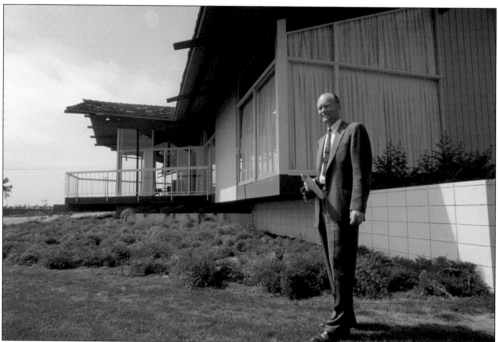

AL OSTERHUES AT LAGUNA NIGUEL SALES OFFICE, 1960. Iver O. Hanson joined the staff of Cabot, Cabot & Forbes as vice president in charge of its California office in 1959. His background was as general manager of the 16,000-acre Palos Verdes development over the previous six years. The construction work was under the direction of Bill Beck, another vice president. (OCA, Alfred B. Osterhues Collection.)

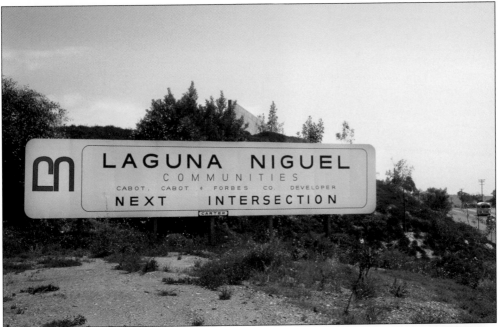

COMMUNITY IDENTIFICATION SIGN, 1960. At the entrance to the community along Coast Highway, this early promotional sign identified Laguna Niguel and Cabot, Cabot & Forbes. The logo was the modified Rancho El Niguel branding iron. The lowercase letter "r" had an added horizontal bar to appear as an "L"; and the curved lowercase "n" remained. (KFA and DPHS.)

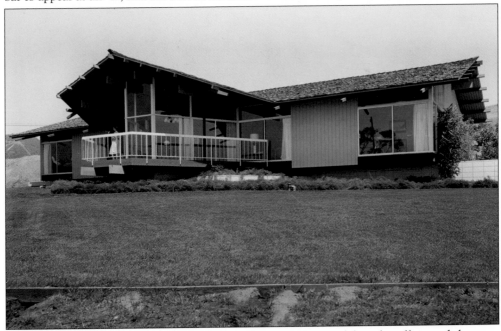

SALES OFFICE, VIEW FROM COAST HIGHWAY, 1960. The design of the sales office used the same characteristics of the original houses planned for Laguna Niguel: sloped, exposed roofing; post-and-beam structure; glass walls and transom windows; vertical wood siding; rectangular concrete block footings and walls, and ground-covering shrubs that linked the structure to the site. (KFA.)

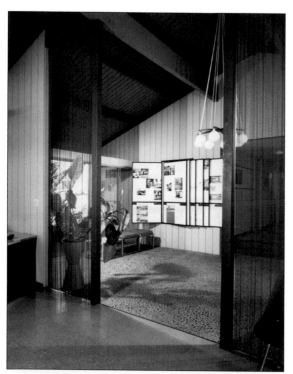

ENTRANCE LOBBY, SALES OFFICE, 1960. The open interior of the offices created an indoor-outdoor connection related to the gentle climate of the site. The upper-income market that was the initial focus of the development also related to the projected development costs in 1959 of $400 million. (KFA.)

ARCHITECTURAL HIGHLIGHTS, SALES OFFICE, 1960. The sales office integrated structural components that would be in the houses throughout the community. Surfaces transitioned through glass walls, windows, and sliding doors, wood and plaster walls and ceilings, and concrete pebble flooring to blend the landscape and unobstructed ocean and hillside views into the house design. (KFA.)

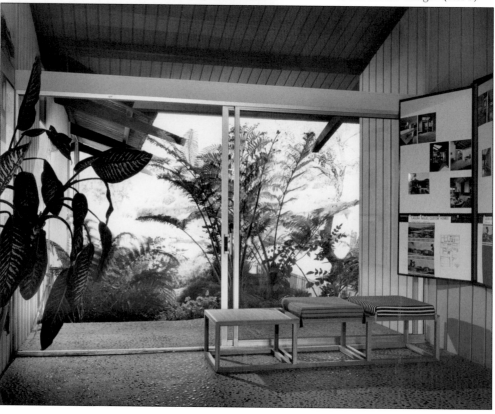

RECEPTIONIST LOBBY, SALES OFFICE, 1960. The design of the sales office was an architectural highlight. The transition area between interior walls and the openings was done with curtains of dark chain-link mesh. The receptionist desk allowed for multiple customers to have plenty of space. (KFA.)

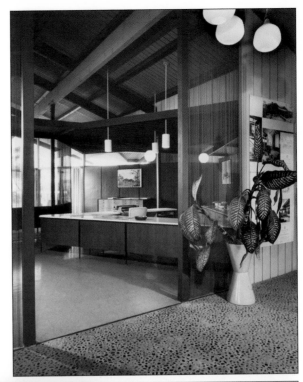

EXTERIOR VIEW DECK, SALES OFFICE, 1960. From the peaked roof area in the center of the building, visitors could step out onto the patio deck and see a wide ocean view. (KFA.)

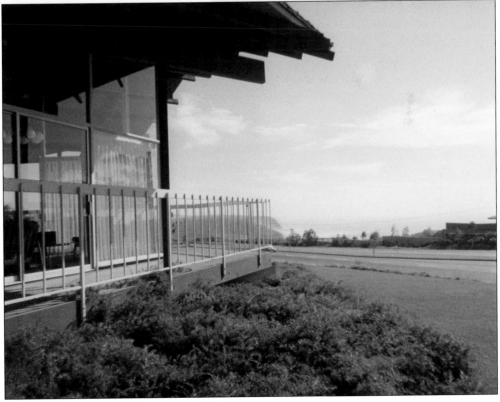

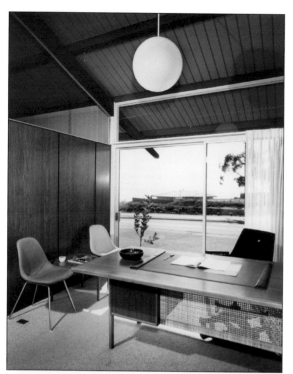

SALES OFFICE AGENT DESK, 1960.
The private offices, where customers
signed documents and met with
sales agents, were completely
enclosed and private but had glass
walls and transom areas for views.
When meeting with a sales agent,
customers could be making decisions
while looking at the sites where
houses were being built. (KFA.)

EXTERIOR DECK, SALES OFFICE, 1960.
To help customers experience the
architectural and construction aspects
of their upcoming homes, the sales
center provided details for houses of
many styles. This part of the building
provided structural information
about the style of houses that were
being built and demonstrated
views into the houses. (KFA.)

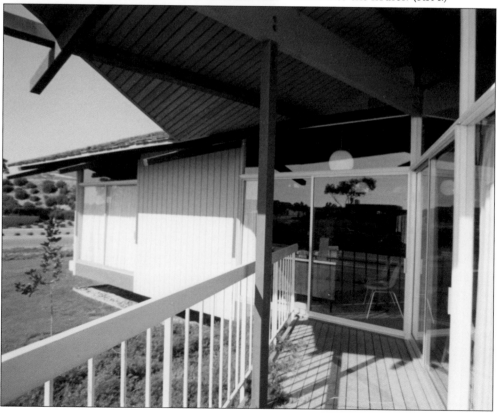

Sales Office Central Space, 1960. The projected peaked ceiling in the central space of the sales office provided wide views of the skyline, coast, and developing property. The seating areas also allowed for discussions on design and architectural models of the houses. (KFA.)

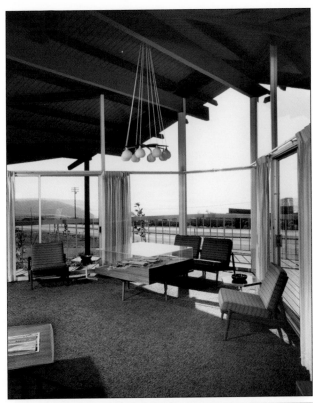

Monarch Bay, Niguel Terrace, and El Niguel Golf Course, June 1961. This aerial view of the Laguna Niguel ranch property is labeled for promotional material. The golf course, in the narrow and steep central valley, had already been graded and landscaped before the Monarch Bay and El Niguel Terrace houses began. (KFA.)

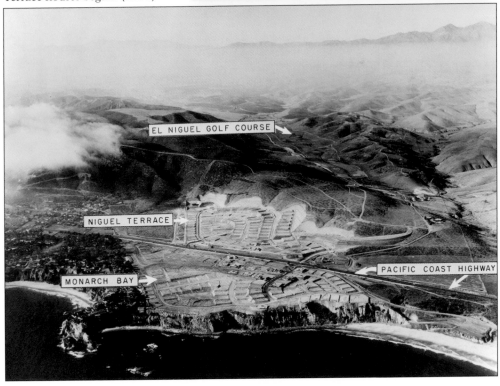

41

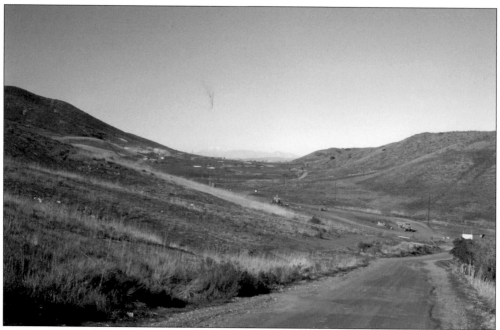

VIEW TO GOLF COURSE, 1960. In early 1960, work began on El Niguel Golf Course. By mid-1960, development started on Monarch Bay and Niguel Terrace. (KFA.)

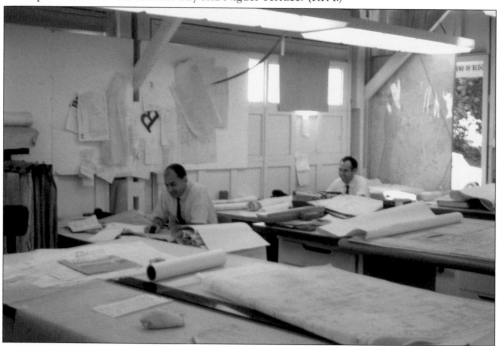

ARCHITECTURAL OFFICES AT NIGUEL RANCH BUILDINGS. Laguna Niguel Corporation work areas for the staff architects, draftsmen, engineers, planners, and assistants were at the ranch buildings at the south end of the golf course. Three architects led the team: Knowlton Fernald Jr., from Stanford University; Ricardo A. Nicol (left), from the University of Southern California; and Arthur R. Schiller (right), from Columbia University. (RNA.)

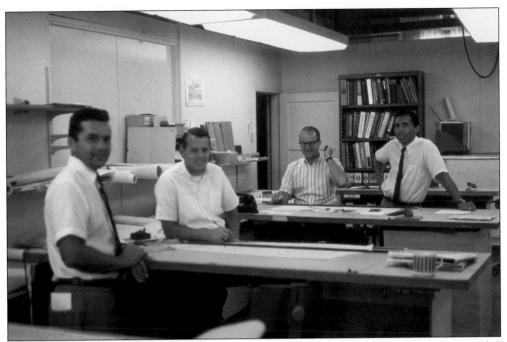

ARCHITECTS, DRAFTSMEN, AND ENGINEERS. Additional architectural staff members also provided assistance and coordination with well-known outside architectural firms. Laguna Niguel Corporation architectural staff included, from left to right, Mitch Croll, Jim Lyons, Len Ritter, and Carl Iverson. (RNA.)

ARCHITECTURAL STAFF EXPANDS. The three key staff architects wished to demonstrate that when planning a community, the design of houses, sites, landscaping, and neighborhoods was one inseparable challenge. Architect Kevin Roche is at left. (RNA.)

MORGAN "BILL" EVANS, LANDSCAPE ARCHITECT, 1960. Evans had been part of Southern California's horticulture and landscaping community for 30 years prior to creating the landscape design for Laguna Niguel starting in 1959. In 1952, Walt Disney hired Evans for the garden at his home in Holmby Hills. In 1954, Evans was hired by Disney to lead the landscape design for Disneyland and other Disney parks worldwide. (RNA.)

LARGE TREES SELECTED, 1960. Morgan Evans visited the Laguna Niguel site biweekly from Friday through Sunday and walked the entire site for a few years with architect Ricardo Nicol. Rather than draw plans, Evans would stake every tree location and specify the tree species. Nicol would add identification numbers to the stakes and update the landscape plans during the hikes. (RNA.)

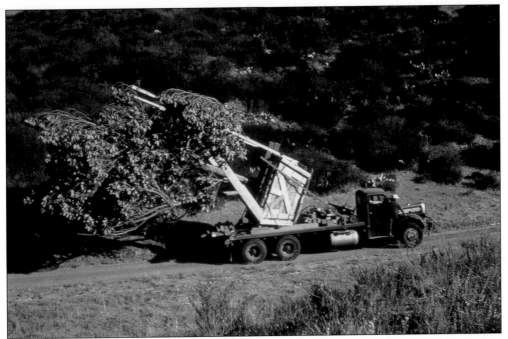

Transporting Trees on the Ranch, 1960. Moving large trees across such steep terrain was not a simple job. The largest trees were not transported along Coast Highway because of the many overhead utility lines in Laguna Beach and Dana Point. Instead, the trees were trucked on dirt roads from the northern end of Laguna Niguel ranch. (RNA.)

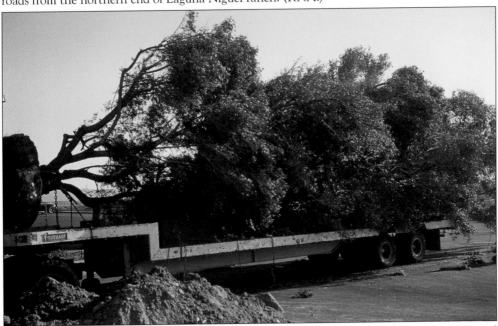

Olive Trees from San Diego County. Thousands of olive trees were brought to Laguna Niguel from northern San Diego County during the 1960s as historic olive orchards were being cleared for future development in that county. Morgan Evans saved the trees as part of the 180-year history of Mediterranean olive trees in Southern California. (RNA.)

Advertising images of families on the beach, golfing, enjoying playgrounds, riding horses, and hiking helped promote the community. A November 1960 article in *Fortune* magazine noted that the area of Laguna Niguel was bigger than Beverly Hills and Santa Monica combined, which was a reference to the ocean and inland settings along with the demographics of the planned community. (KFA.)

LEARNING ABOUT LANDSCAPING AT DISNEYLAND, 1960. Al Osterhues spent time at Disneyland beginning in 1960 looking at landscaping work with Laguna Niguel's chief landscape architect, Morgan "Bill" Evans, who was also the director of landscape architecture at Disney for Anaheim, Orlando, Paris, Tokyo, and Hong Kong from the early 1950s through the 2000s. (OCA, Alfred B. Osterhues Collection.)

ENTRY CORNERS AT COAST HIGHWAY, 1960. Two large trees were planted on the north and south side of Coast Highway at Crown Valley Parkway, across from the Laguna Niguel sales office. (RNA.)

NEIGHBORHOOD SIGNAGE ON COAST HIGHWAY, 1961. Community signage was created for Monarch Bay and Niguel Terrace at the Laguna Niguel entrance on Coast Highway and Crown Valley with raised custom metal lettering on curved block walls. This same thematic design was later installed for neighborhoods throughout the ranch. (KFA and DPHS.)

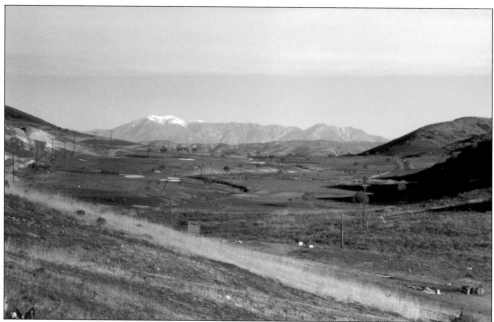

El Niguel Golf Course, 1960. Work on the golf course started before the construction of any houses in the community. The purpose of the golf course was, as stated in the planning report, to "give impetus to the recreational character" of the ranch, to bring people into the central portion of the ranch during the first stages of development, to encourage a general public interest, and to create desirable homesites in the interior of the ranch. (RNA.)

El Niguel Plantings Begin, 1960. While grading and planting started in early 1960, the model country club and golf course was displayed as a 12-foot-long replica of over 160 acres that made up El Niguel Country Club. It was displayed at the first annual Sports, Vacation and Travel Show at the Los Angeles Memorial Sports Arena from February 27 to March 6, 1960. (RNA.)

VARIETY OF TREES, 1960. The golf course's original tree landscaping, by Morgan Evans, began in March 1960. Each green was surrounded by a different species of tree, many of them not found on any other golf course. The trees were planted up to two years before the complete course opened. The back nine (which is now the front nine) opened to members in August 1961. The front nine (which is now the back nine) opened in June 1962. (KFA.)

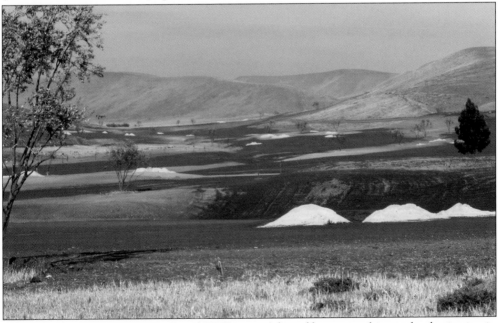

GOLF COURSE GRADING, 1960. David W. Kent was the golf course architect who, beginning in 1959, planned the two original sites for a public course and a private course in Laguna Niguel. The site work on his designs for El Niguel Country Club began with grading in early 1960, with the front and back nine completed in 1961 and 1962. The course was later modified by golf course architects Ted Robinson and Ted Robinson Jr. (KFA.)

Planned El Niguel Country Club Design, 1960. Mosher & Drew designed the proposed country club building and provided this rendering used in publications throughout the country. A similar design was built three years later as an office building in Monarch Bay Plaza. (RNA.)

Hillsides for Golf Course Views, 1961. Original plans for neighborhoods on hillsides overlooking the course were created beginning in 1959. The earliest grading for development of houses overlooking the course began in 1962. (RNA.)

"Artfully Planned Layout," 1960. The site work on El Niguel Country Club was started months earlier than site work at the Monarch Bay and Niguel Terrace homesites. In 1961, El Niguel Country Club was called by some professional golfers the most artfully planned layout in the world. (KFA and DPHS.)

Great Distances down the Fairways, 1961. After the course had been planned and charted, the grading and construction of the fairways, tees, and greens began. Tree locations were staked, shrub areas were marked, and the plantings began. The residential custom lots overlooking the fairways were then laid out to provide exceptional views for the homeowners while not interfering with any golfers' long-distance shots. (KFA and DPHS.)

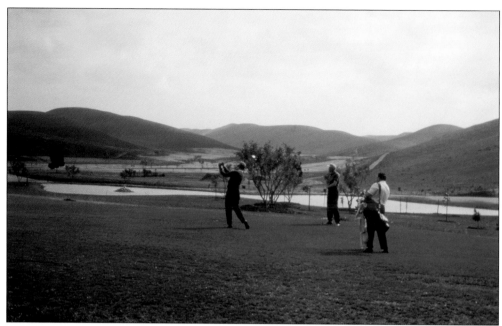

Promotional Images of El Niguel, 1962. Before the golf course opened to members, the course was actually playable. Promotional photographs were staged starting in 1961, and professional golfers and course experts played the course regularly to provide insight, critique, and advice in adjusting the course construction from the very start of the work. (KFA and DPHS.)

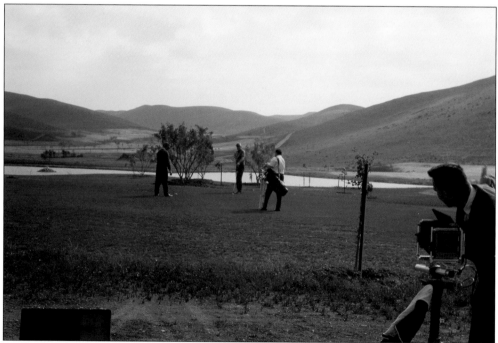

Photographers on the Course, 1962. Noted professional photographers were hired by Laguna Niguel Corporation from 1961 to 1962 to take photographs on the golf course before it officially opened to members. (KFA and DPHS.)

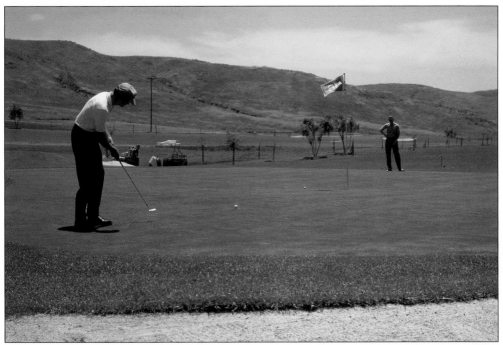

IMAGES FOR GOLF PROMOTION, 1962. Images taken throughout the El Niguel Country Club golf course were used as promotional material in newspapers and magazines and in golf-oriented publications nationwide. (KFA and DPHS.)

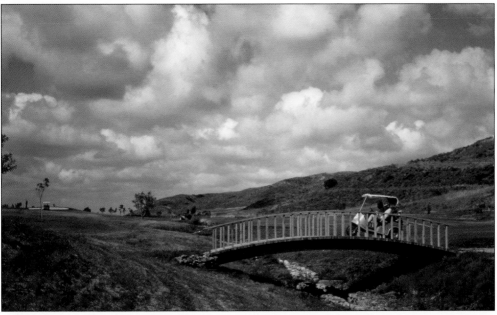

UNIQUE VALLEY CLIMATE, 1962. The narrow valley location of the golf course gives it a unique climate. The cloud formations enter the valley on gentle ocean breezes from the south-facing connection to the Pacific Ocean. Lower summer temperatures, daily mist, light fog, and the very high hilltops along the coast to the west create a natural environment at the golf course that is unique to Laguna Niguel. (KFA and DPHS.)

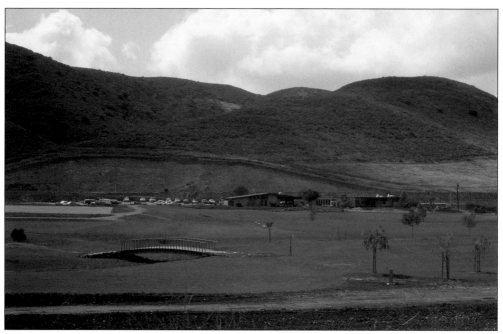

CLUBHOUSE BUILDINGS, 1962. Mosher & Drew and Schwager & Ballew designed the two modern-style houses that were used as temporary club facilities at the original first tee for El Niguel Country Club. These would be club facilities for about a decade. The larger, permanent clubhouse was then built across the course, and these two original structures were sold as houses. (RNA.)

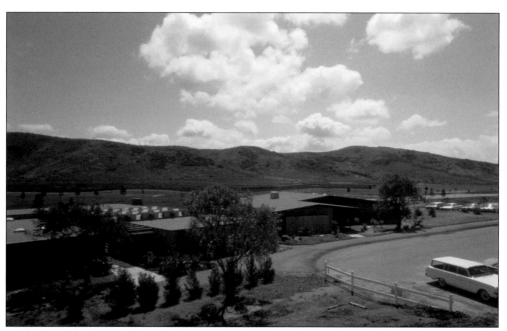

CLUBHOUSE FACILITIES, 1963. Using two custom model homes for the country club facilities, with construction on the buildings starting in 1961, allowed the entire 18-hole golf course to be fully open for members in 1962. This later became Westgreen Drive. (RNA.)

GOLF AND SOCIAL CLUB, 1963. All residents were welcome to the private club. The spatial separation of the two buildings' entrances allowed social members to enjoy one entrance to the lounge, social, and dining areas. Across the courtyard, golfing members could enter the second structure, with a golf shop, a locker facility, and access to golf hitting nets, golf bag and club storage, and cart parking. (KFA and DPHS.)

EL NIGUEL CLUBHOUSE, 1963. Between the two structures was a courtyard patio used for access to golf carts and outdoor events. (KFA and DPHS.)

VIEW TO THE CLUBHOUSE, 1962. From the future site of the current El Niguel Country Club on the eastern side of the first tee, this view looks west toward the location of the original clubhouse structures. (KFA and DPHS.)

STOCKHOLDERS MEETING AT CLUBHOUSE, 1962. Laguna Niguel Corporation held the stockholders meeting at the El Niguel Country Club. The meeting included a very large display of drawings, images, and architectural models. (RNA.)

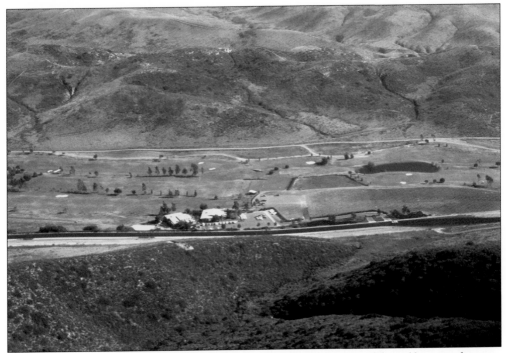

ORIGINAL CLUBHOUSE BUILDINGS, 1962. From the hillside to the west of the golf course, this view takes in the two original country club buildings. The buildings, designed in 1960 and constructed starting in 1961, were planned to become residences when the much larger country club facility was built across the course. The building on the right remains as the oldest residential site within the city of Laguna Niguel. (RNA.)

ENTRANCE TO EL NIGUEL COUNTRY CLUB, 1962. Members entered the golf course from Crown Valley Parkway, approximately one and a half miles from the coastline. (RNA.)

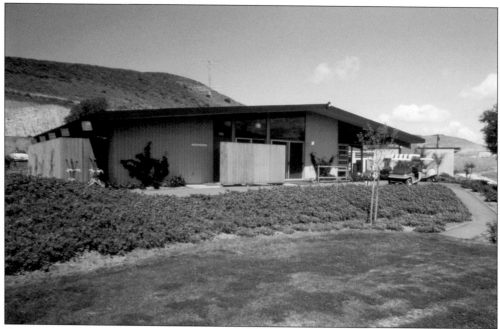

GOLF CLUBHOUSE, 1962. For golfers, this building provided locker rooms, social areas, and facilities for checking into the club and obtaining golf carts. The facility also housed manager and staff offices. (KFA and DPHS.)

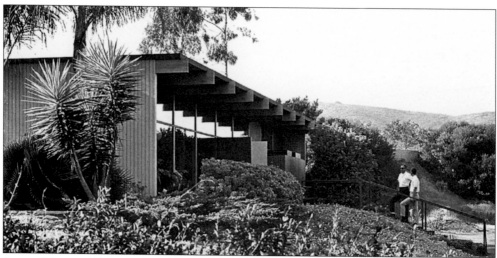

SOCIAL MEMBERS CLUBHOUSE, 1962. For club members, both golf and social, the second building was for dining and social events. The flat-roofed, post-and-beam, glass-walled design, which was designed to eventually become a house, also served as a design inspiration for other houses surrounding the golf course and in other neighborhoods. (LLA.)

CANYON, LAKES, AND STREAMS ON THE COURSE, 1961. The long, narrow El Niguel Golf Course is played up one side of the canyon and back down the other. As noted in original descriptions, fairways are somewhat wider than expected and less hilly than they look. Hazards include two lakes and a large reservoir affecting six holes. A stream running through the middle of the back nine (now the front nine) enhances all its fairways. (KFA and DPHS.)

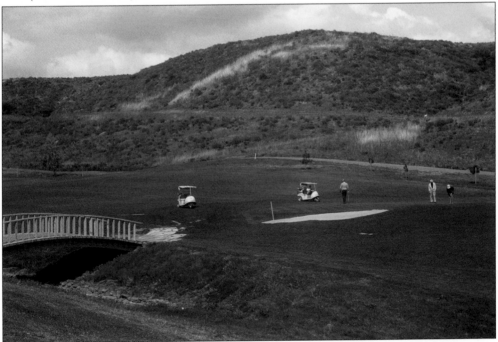

BRIDGES AND STREAMS AT EL NIGUEL, 1962. The styling of bridges on the course was meant for unique beauty and functionality in ways that referenced Asian design. A running brook traverses the entire nine southern fairways. Multiple lakes and dry stream beds meander through the entire course. (KFA and DPHS.)

NORTH FAIRWAY VIEW, 1962. From the lake south of the clubhouse, this view looks inland. The two structures in the center are golf course maintenance and landscaping facilities. (RNA.)

FAIRWAY VIEW TO THE PACIFIC, 1962. When all the fairways at El Niguel Country Club were completed, it was the longest golf course in California at that time. (KFA and DPHS.)

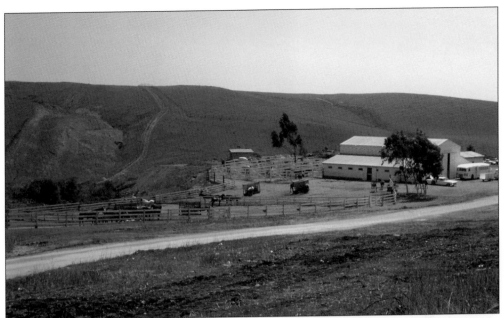

HORSE RIDING STABLES EXPAND, 1962. Additional riding club facilities expanded within the same group of buildings that once were headquarters for the Niguel Ranch. The horse stalls, club offices, and riding ring were in Crown Valley, just south of El Niguel Country Club, less than half a mile from Coast Highway. Horses from the riding club appeared in the 1962 Tournament of Roses Parade in Pasadena. (RNA.)

RANCHO NIGUEL RIDING CLUB, 1962. With the golf course completed, other portions of the ranch were now easily accessible by trails for children and adult horse riders. Nearly 90 miles of riding, hiking, and bicycle trails were planned within the rancho. The stable corrals could now accommodate more horses and allowed for both Western- and English-style riding. (OCA, Alfred B. Osterhues Collection.)

SPRING BLOSSOMS IN THE VALLEY, 1962. Blossoming hillsides flanked the golf course. Some of these lower hillsides in the natural landscape, lower than 400 feet in elevation, varied seasonally. The taller slopes, up to over 900 feet, usually remained the same throughout the year. (OCA, Alfred B. Osterhues Collection.)

SLOPE LANDSCAPING AND SHRUBS, 1962. Morgan Evans (right) created a landscaped terrain with the intention of transforming the barren site of the ranch over decades with drought-tolerant hillside plantings. Evans regularly visited the entire ranch to design and plan the landscaping of the inner valley and hillside areas before and during the design and grading process. (RNA.)

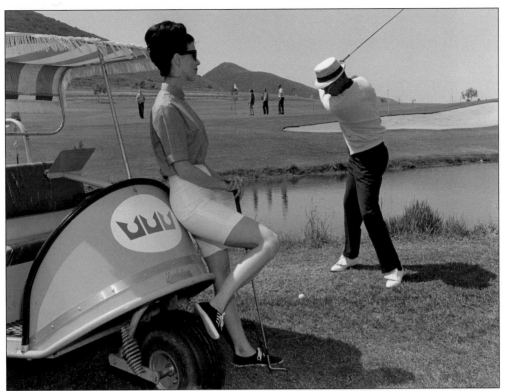

NEW MESSAGE FOR THE "NEW TOWN," 1962. In creating the goals of the community in advertising, it was important that Laguna Niguel was the "New Town" where women could be involved in all aspects of the community. In this promotional photograph and others, it was not simply about being only a housewife; the messages were focused on empowering women as an important part of the new town. (KFA and DPHS.)

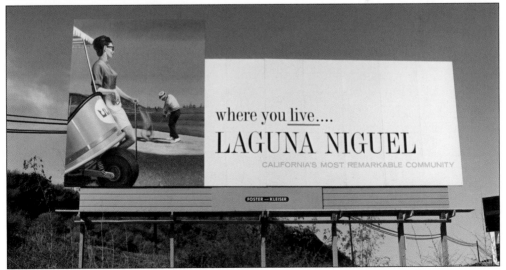

ADVERTISING BILLBOARD, ORANGE COUNTY, 1963. Along the freeway at the northern entrance to Laguna Niguel, a billboard was created to promote the community. An artist did this oil painting for the billboard, copying the photograph that was used in promotional materials. (KFA.)

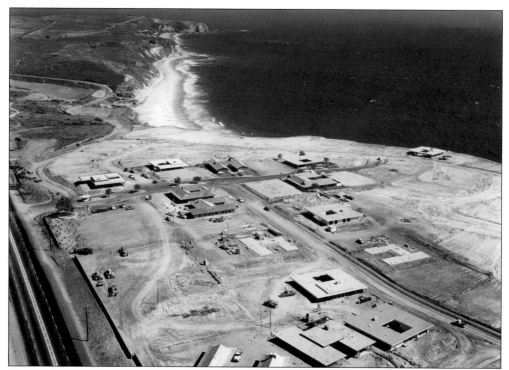

HOUSE CONSTRUCTION, MONARCH BAY, JUNE 1961. The official public opening celebration for the 7,000-acre master-planned community of Laguna Niguel and the preview showing of three decorated homes in Monarch Bay were on Sunday afternoon, July 9, 1961. A private invitation went to investors and the press. Though houses and lots had already been sold by this time, this event helped generate more media attention. (KFA.)

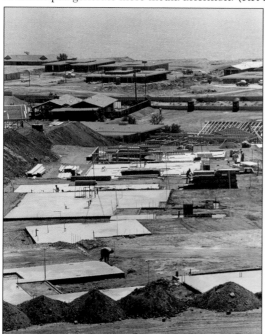

MONARCH BAY AND NIGUEL TERRACE CONSTRUCTION, JULY 1961. Hess Construction Company of Long Beach moved hundreds of thousands of cubic yards in very early grading operations, helping to retain and secure hillsides and sculpting valley areas. Hess did the initial site development work for Monarch Bay, Niguel Terrace, and the golf course. (KFA and DPHS.)

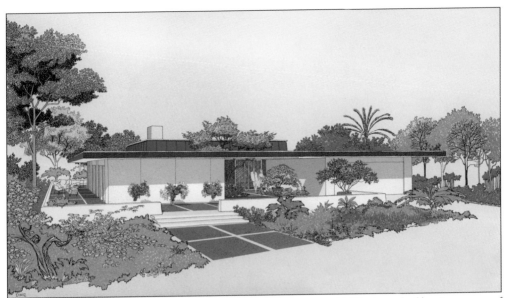

LADD & KELSEY ARCHITECTURE, CARLOS DINIZ RENDERINGS, 1960. A goal of having many of the houses in Monarch Bay designed by the Pasadena-based architectural firm of Thornton Ladd and John Kelsey was to serve as a quality guide for other homes in the community. As stated by Laguna Niguel Corporation: "To fashion a shelter for man from the materials of nature not only gratifies his senses but refreshes his spirit." (RNA.)

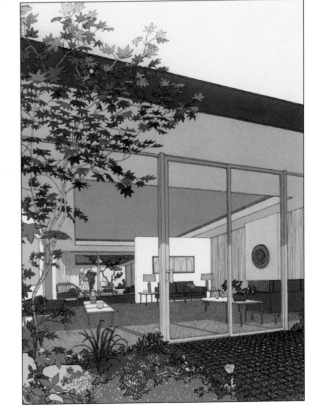

VIEW FROM PATIO TO INTERIOR AND COURTYARD, 1960. The Ladd & Kelsey architecture firm was responsible for the design of the Pasadena Museum of Art (which is now the Norton Simon Museum), a Busch Gardens theme park in Van Nuys, buildings on the campuses of the University of Southern California and Occidental and Claremont Colleges, and the main building on the CalArts campus. Ladd and Kelsey attended the USC School of Architecture. (RNA.)

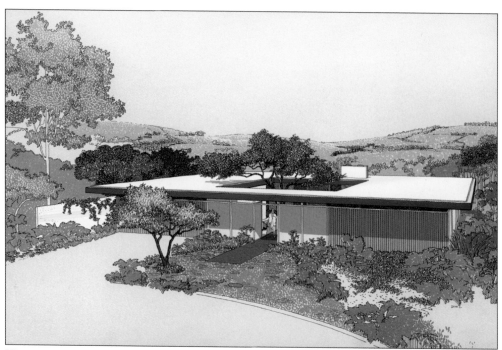

HILLSIDE LOCATIONS WITH INLAND VIEWS, 1960. Ladd & Kelsey created the complete openness yet privacy of the house designs to enable a variety of activities to occur simultaneously and independently. Many of the floor plans feature wings around a central courtyard and pool area with sliding glass doors opening to dining, kitchen, and living spaces across a courtyard galleria, as rendered by Carlos Diniz. (RNA.)

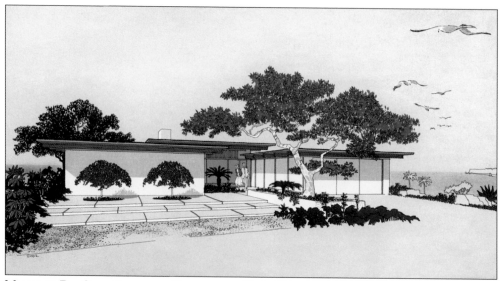

MONARCH BAY SALES BROCHURE RENDERINGS, 1960. What were often referred to as "magnificent coastal views" in publications were truly an integral part of many of the earliest houses in Laguna Niguel. And the views of either "blue water breaking on the shore or views of distant green mountains" set the stage for how sites were designed to allow for the most unobstructed views. (RNA.)

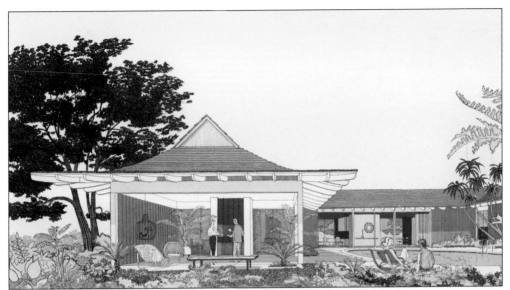

EXTERIORS AND INTERIORS, 1960. Besides the tract development houses within Monarch Bay designed by Ladd & Kelsey, additional lots throughout Monarch Bay and Niguel Terrace were intermixed for custom homes by a variety of architects. But the development houses presented the desired design from three basic ideal forms for the architectural mass—work areas, sleep and quiet areas, and settings for relaxation. Houses in this style would soon be built within the inland neighborhoods. (RNA.)

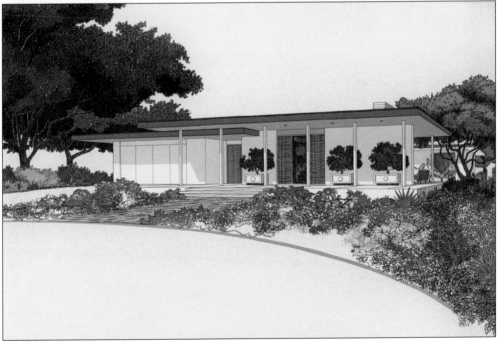

INDOOR AND OUTDOOR PRIVACY, 1960. A goal of Laguna Niguel Corporation was to design houses with color, mood, form, and light and shadow patterns that could be a part of an everyday living experience. The company's goal was to present what it hoped would be a way of life unparalleled elsewhere in the nation. (RNA.)

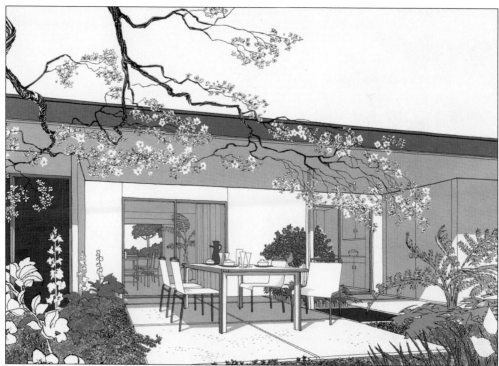

PRIVATE PATIOS, OUTDOOR DINING, 1960. Ladd & Kelsey house designs were for "a life that largely takes pleasure from ever-changing views, the gardens, and pool." The components of all houses then planned for Laguna Niguel correlated to serve the theme of California indoor-outdoor living. This rendering is by Carlos Diniz. (RNA.)

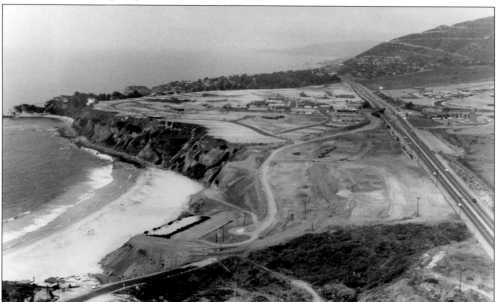

MONARCH BAY SITEWORK EXPANDS, 1961. The property south of Monarch Bay was roughly graded very early and would later become the houses of Monarch Bay Mall. On the beach is the graded site for the upcoming Monarch Beach Club. (KFA and DPHS.)

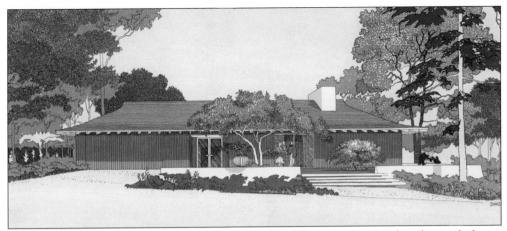

SIMPLE YET ELEGANT DESIGNS, 1960. Carlos Diniz's hand-drawn and -painted renderings for house designs were silk-screened in full-color palettes on warm, textured paper. These sales brochures included single prints of each exterior elevation, floor plans, and interior and exterior renderings. His designs for every project within Laguna Niguel linked aesthetic connections throughout the community. (RNA.)

MONARCH BAY MODEL HOME, OCTOBER 1961. Monarch Bay houses were occupied by residents through leaseholds on the land. Houses by Ladd & Kelsey, AIA, were built by LNC Construction Company, a wholly owned subsidiary of Laguna Niguel Corporation. Lots in Monarch Bay were also available, leased individually, for the construction of custom homes. (KFA.)

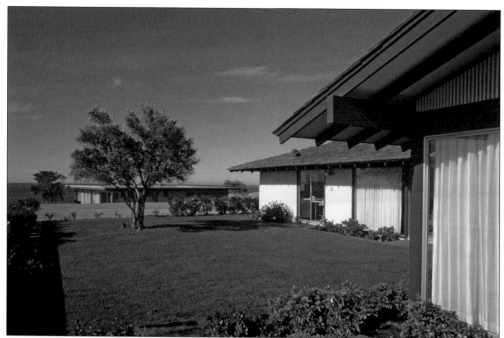

LANDSCAPING, MONARCH BAY MODEL HOME, OCTOBER 1961. The use of nature as a basic ingredient in 20th-century architecture reaches a high art form in the Ladd & Kelsey home design. Not long before 1960, landscaping was considered an embellishment after the fact, but for the designs in Laguna Niguel, Knowlton Fernald wrote, "landscaping is so much an integral part of our design for living that it can no longer be left to the last or omitted from architecture." (KFA.)

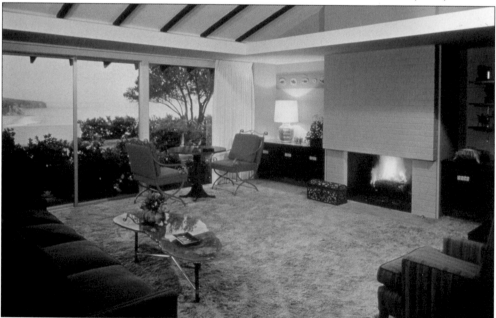

BEST IN AMERICA, 1961. This four-bedroom model home, overlooking the Pacific Ocean in Monarch Bay, was chosen by a variety of publications as one of the 20 best contemporary architecturally designed homes in America constructed in 1961. (KFA.)

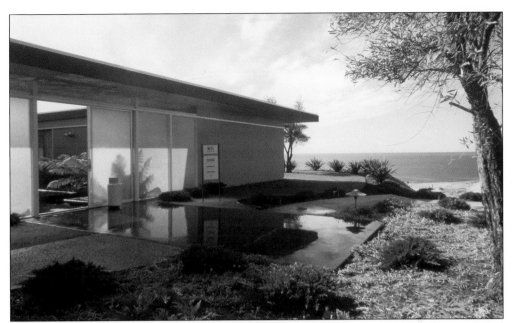

MONARCH BAY MODEL HOME, TRANSLUCENT EXTERIOR ENTRY, OCTOBER 1961. Laguna Niguel Corporation sales brochures were meant to inform and inspire residents. A house designed by Ladd & Kelsey created garden and distant views that were meant to allow homeowners ways to experience positive visual and emotional lifestyles in the community. (Author's collection.)

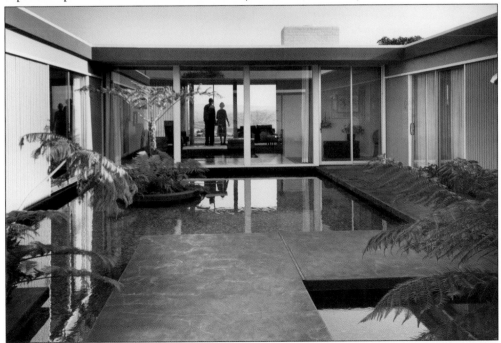

LADD & KELSEY, ENTRY COURTYARD, OCTOBER 1961. The requirements for the design and promotion of the earliest houses related to the garden as a personalized expression of natural reality and search for tranquility. Through renderings, text, and photographs, these messages in advertisements and articles reached the intended residents. (KFA.)

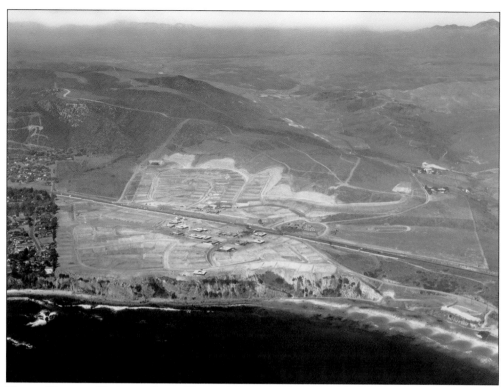

NIGUEL TERRACE, NORTH OF COAST HIGHWAY, JUNE 1961. Many of the homes in this neighborhood were designed by Schwager & Ballew, a Newport Beach architectural firm. Lot sizes average 10,000 square feet, including the slopes, and the original houses were to be five-bedroom, three-bath residences from 2,400 to 2,800 square feet. This project later expanded toward the top of the ridge and east to Crown Valley Parkway. (KFA.)

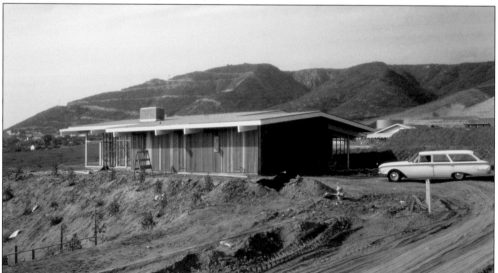

MODERN DESIGNS IN NIGUEL TERRACE, 1961. Some of the first houses in Niguel Terrace were smaller than originally planned but were creatively designed and constructed with exposed wood, sloped ceilings, large areas of glass, and deck patios. (OCA, Alfred B. Osterhues Collection.)

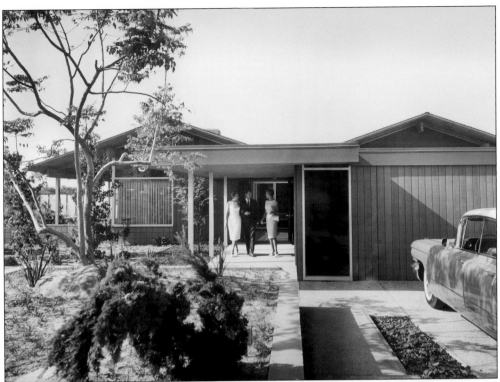

MID-CENTURY MODERNS, 1961.
With 22 houses under construction
in the first phase of Niguel Terrace,
the model homes opened on
September 3, 1961. There were 300
lots originally planned for the Niguel
Terrace neighborhood. (KFA.)

**MODEL HOMES AND PLAYGROUND,
1961.** The model homes in Niguel
Terrace were uniquely sited and
cleverly marketed. A children's
playground was built in a backyard
of one of the model houses. The
goal was to encourage younger
families to enjoy the houses in
this neighborhood, which was
more affordable than Monarch
Bay. Laguna Niguel Corporation's
architect, Knowlton Fernald, often
brought his wife and children
to the sites in Laguna Niguel
on the weekends for publicity
photographs. In this photograph
are Fernald's wife, Marguerite; their
son, David; and, on the turtle,
their daughter, Janie. (KFA.)

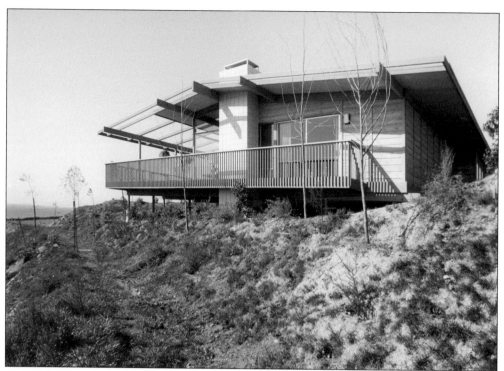

SIMPLISTIC MODERNITY, 1963.
In 1963, this house, credited to
the Laguna Niguel Corporation
architectural team Fernald,
Nicol & Schiller, was primarily
a project of Ricardo Nicol. The
1,765-square-foot house was a
single story. A spacious deck,
18 by 28 feet, provided outdoor
dining and entertaining, with
connected deck areas to the
bedroom and kitchen. (RNA.)

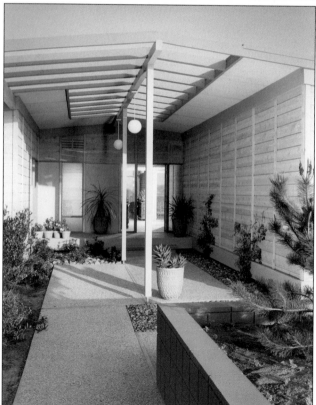

**NATURAL WOOD AND MODERN
STRUCTURAL ENGINEERING,
1963.** The central courtyard
entrance had an open
trellis, providing even light
throughout the day. The
exterior was horizontal wood
siding in a natural finish.
The eaves, rafters, posts, and
doors were painted various
rich colors that enhanced
the environment. (KFA.)

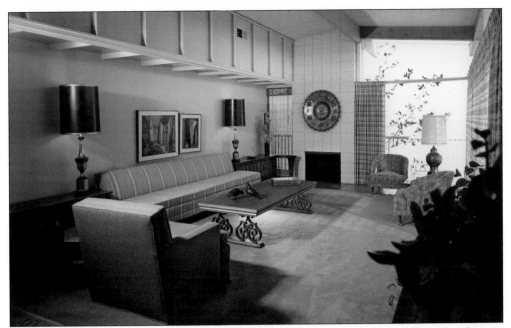

WOOD, CONCRETE, AND LIGHTING, 1963. The house had stained cedar walls and ceilings, a concrete block fireplace, and built-in lighting. The living room was centrally positioned for access to the large deck, which was also accessible from the dining room and kitchen. (KFA.)

BRICK TILE FLOORING AND NATURAL WOOD CABINETS, 1963. The open-space planning of this house was a design that was somewhat experimental with the developers. The idea was to start with this unique house design so that the upcoming developments in Laguna Niguel would use similar concepts. (KFA.)

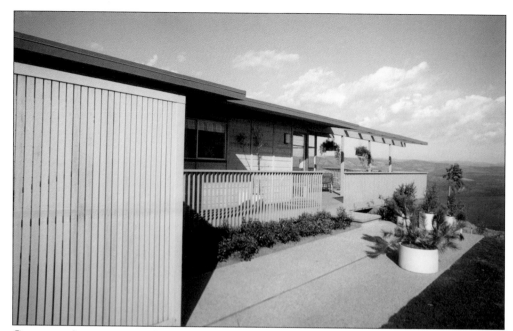

COMPLETE ACCESS TO THE HOUSE, 1963. The broad views for so many of the sites in Laguna Niguel required that the designs would not obscure views from adjacent properties. Designs also provided full access to the gardens from the houses. Rather than have narrow side yards that would become unattractive, the goal at this house designed by Nicol was to relate the site to open space and views. (RNA.)

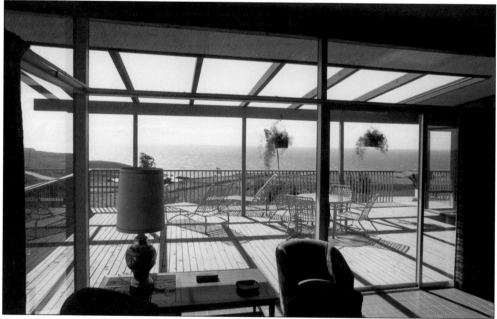

INDOOR VIEWS TO HILLS AND OCEAN, 1963. The wraparound decks always provided distant views. The goal of the architects for the Laguna Niguel houses was to also provide wide views from inside the house. This created interior privacy so that only a few window coverings were needed for blocking interior heat gain or loss. (KFA.)

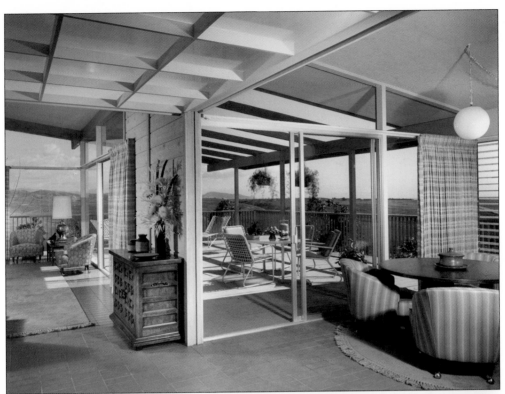

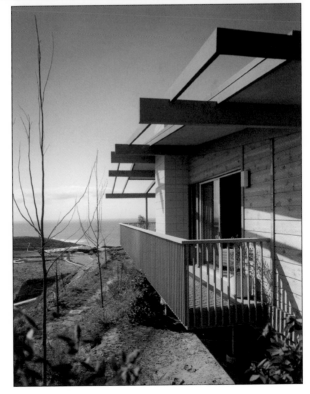

INTERIOR AND EXTERIOR SPACES, 1963. Laguna Niguel Corporation's architectural designs, as shown in this house by Nicol, blended indoor and outdoor space to take advantage of the very gentle climate and excellent views. The central spatial area had a horizontal wood grill and a translucent panel below the exposed ceiling. This was gently lit from above in the evening. (RNA.)

PRIVATE OUTDOOR DECK AREA, 1963. The deck extended past the living room to a bedroom, providing a private outdoor area. Most lots on hillsides in Laguna Niguel were positioned to follow the existing steep contours. The staggered lots provided privacy and unobstructed views related to the adjacent lots. This house was featured in many publications, including the May 24, 1964, *Los Angeles Times Home* magazine. (RNA.)

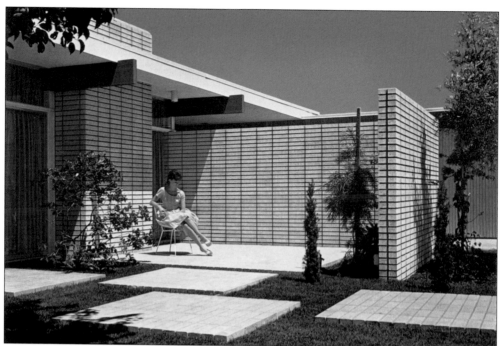

Schwager & Ballew, AIA, 1961. Niguel Terrace houses built by Cabot, Cabot & Forbes's Laguna Niguel Corporation were varied and interesting designs by the architectural firm that did many designs throughout Laguna Niguel. The landscape design was by Eckbo, Dean & Williams. This house was in the October 1961 *Sunset* magazine. (KFA.)

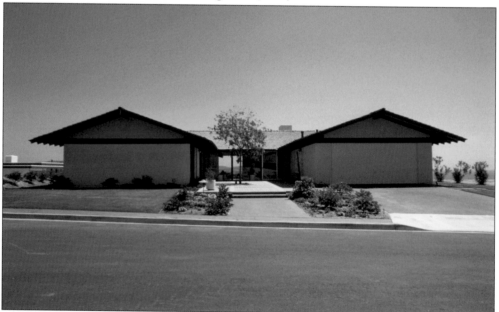

Niguel Terrace Wide Lots, 1962. The 300 planned lots on this steeply sloped site were usually a minimum of 10,000 square feet. The designs often have the entrance through a recessed courtyard to a glass-walled corridor that frames the view. The house seen to the left is at a lower level. Lots were stepped so that every lot had an unobstructed view. (KFA.)

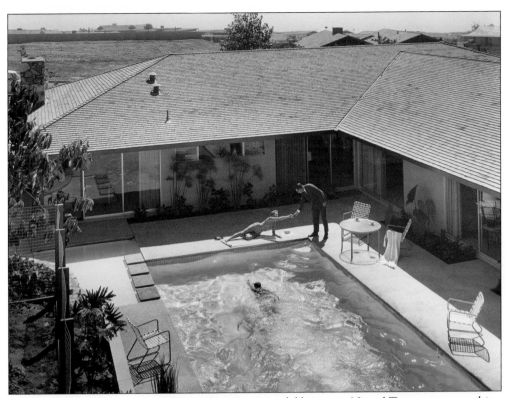

SWIMMING POOL COURTYARD, 1962. The various model homes in Niguel Terrace were reaching a wide market. The plans offered large lots and interesting houses. Each floor plan was designed to link to the garden. In this model, the house wraps around a swimming pool. (KFA.)

EARLY SLOPE PLANTINGS. The natural soil composition on slopes throughout the community was a challenge for the landscape architects, including Morgan Evans and also the firm of Eckbo, Dean & Williams. To protect the slopes, long-term natural plantings were placed, and then fast-growing ground covers and small shrubs were spray-seeded on the slopes. The long-term growth of more native specimens required less irrigation. (RNA.)

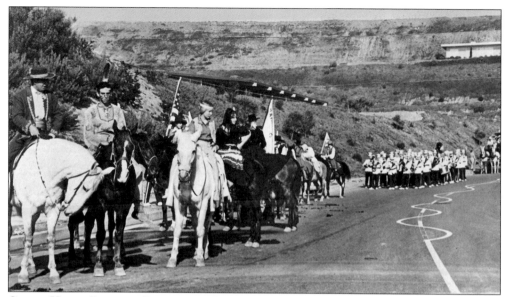

CROWN VALLEY PARKWAY CELEBRATION PARADE, DECEMBER 5, 1963. A winding cattle path that meandered through the hills of Laguna Niguel for almost 200 years became the major artery connecting Coast Highway and the San Diego Freeway in September 1963. Costumed riders paraded along Crown Valley Parkway with bands, covered wagons, and new and vintage automobiles. (KFA.)

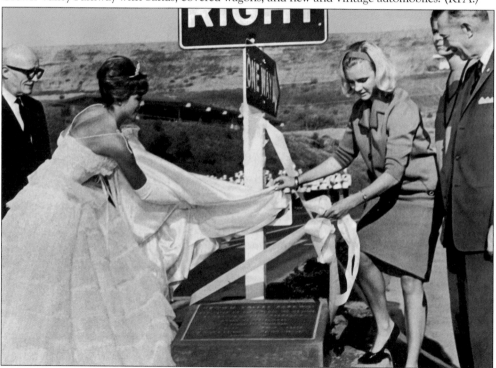

UNVEILING OF PLAQUE, DECEMBER 5, 1963. More than 500 spectators watched the unveiling of the plaque in the center median of Crown Valley Parkway at Coast Highway. Miss San Clemente and Miss Newport Beach uncovered the bronze plaque while county supervisors Alton E. Allen and C.M. Featherly looked on. (KFA.)

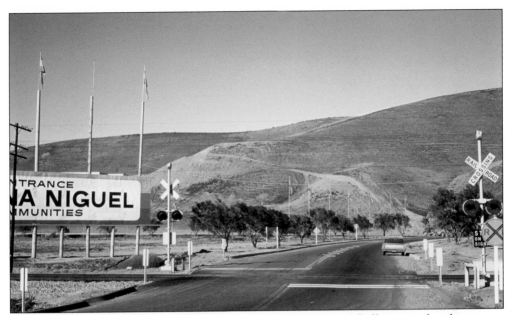

CONNECTIONS TO THE FREEWAY, 1963. Due to the land acquisition challenges, railroad crossings, and the proposed San Diego Freeway improvements at the northern border of the ranch property, Laguna Niguel Corporation's access for Crown Valley Parkway varied. This entrance was north of the current Crown Valley Parkway connection at the freeway. (RNA.)

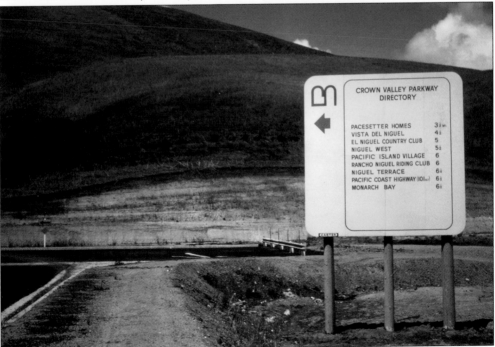

NORTHEAST ENTRANCE OF THE COMMUNITY, 1964. After crossing the railroad tracks to enter Laguna Niguel, the road turned left, then a right turn connected to Crown Valley Parkway. The growing number of early neighborhoods in the community were noted on the entrance signage. (RNA.)

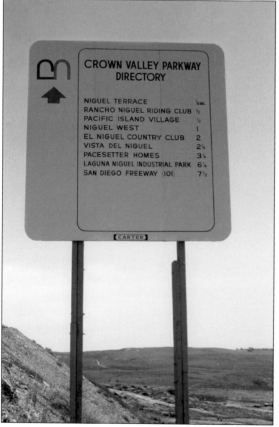

INLAND ACCESS TO THE COMMUNITY, 1963. Among the difficulties facing the developers was the delayed acquisitions at the northeast portion of the ranch of adjacent properties on the other side of the hills in the eastern valley toward Rancho Mission Viejo. Access to Crown Valley Parkway on these roads was a challenge involving many temporary street turns. (RNA.)

COASTAL ACCESS TO THE COMMUNITY, 1964. When Crown Valley Parkway was the connection between Coast Highway and the freeway, the updated signage at the coastal sales office identified the new neighborhoods and facilities within the community. (RNA.)

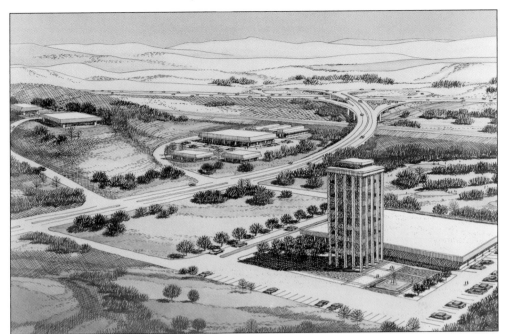

RENDERING OF LAGUNA NIGUEL INDUSTRIAL PARK, 1962. Angelikis & Bailly illustrated the Crown Valley Parkway entrance to Laguna Niguel from the San Diego Freeway. The parkway was opened at this location in September 1963, but the direct freeway connection ramps would happen a few years later. Al Osterhues did the engineering studies for the 220-acre industrial park site. (RNA.)

INDUSTRIAL PARK, 1963. When Crown Valley Parkway exited the Laguna Niguel valley area over the hill toward the San Diego Freeway, this was the planned industrial park site in 1959. That same year, the planners decided that Laguna Niguel was not suited to a regional shopping center and recommended that the location where such a center could succeed would be at Crown Valley Parkway east of the San Diego Freeway. (RNA.)

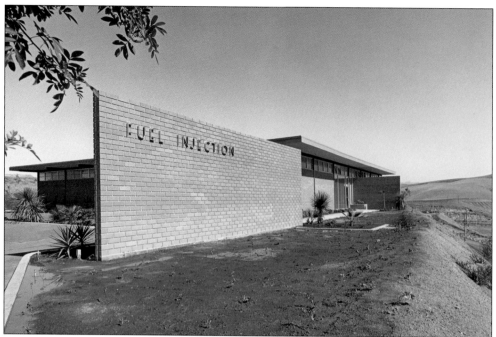

FUEL INJECTION ENGINEERING, 1963. The first building in the Laguna Niguel Industrial Park, Fuel Injection Engineering, was completed in 1963. It was designed by the architects at Laguna Niguel Corporation and built by LNC Construction. It was located at Crown Valley Parkway and Cabot Road. (KFA.)

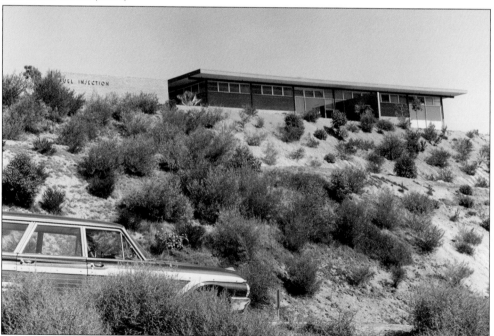

INDUSTRIAL PARK OFFICES, 1963. The architectural style introduced at this site was an important component of the master plan for Laguna Niguel. The community goal was to create modern design that was long-lasting, genuine, and integrated into the natural landscape. (KFA.)

84

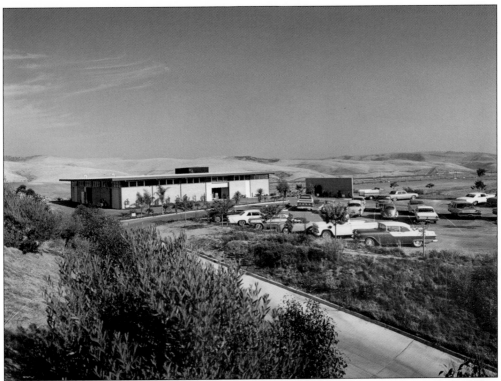

NATURAL SETTING FOR INDUSTRY, 1963. The industrial park was laid out to allow hillside, valley, and mountain views from the buildings by placing the parking areas behind the structures. The parking areas, set back above Crown Valley Parkway, would eventually be screened by landscaping plantings. (KFA.)

INDUSTRIAL PARK SECOND STRUCTURE, 1963. In the lower level of the industrial park, a second facility was constructed along the temporary entry street from Camino Capistrano to Crown Valley Parkway. This entry was Forbes Road. (KFA.)

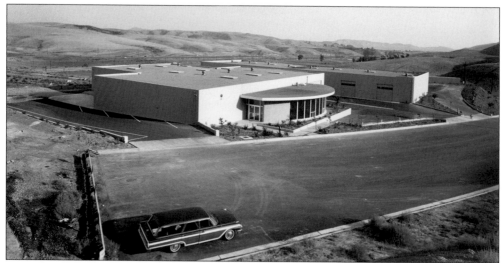

INDUSTRIAL PARK ADDITIONAL SITES AND FACILITIES, 1963. Laguna Niguel Corporation promoted the industrial park area as offering "certain industry an opportunity to establish in a most unfactory-like atmosphere; a clean, green, rapidly developing residential-recreational-business-industrial community. At Laguna Niguel, you and your employees will work (many will live here, too) in one of the nation's finest environments." (KFA.)

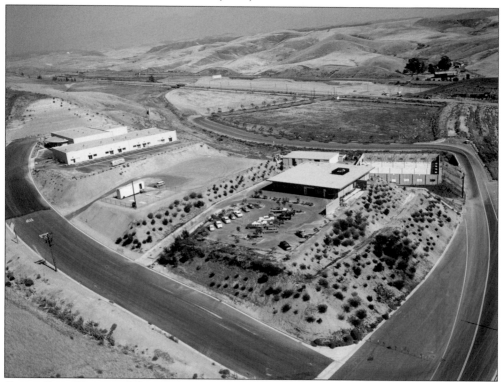

CLARK FOAM FACTORY SITE, 1963. James Pond and Clark Inc. purchased 25 acres and built a 70,000-square-foot plant that became the world's leading maker of polyurethane surfboard blanks at Crown Valley, east of Cabot Road in the Laguna Niguel Industrial Park. The factory, under construction in this image, opened in April 1964. (KFA.)

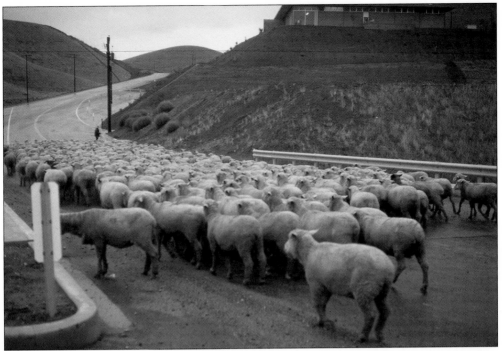

BASQUE SHEEP ARRIVE, 1963. Each year, sheep arrived by train at the northeast corner of Laguna Niguel. Sheep are herded along Crown Valley Parkway in the industrial park and walked into the valley to graze on the hillsides until late in the fall. (RNA.)

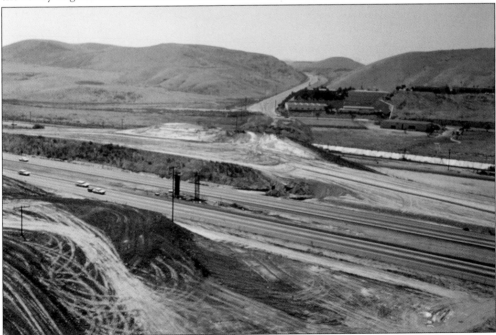

FREEWAY OVERPASS AND RAMP CONSTRUCTION, 1964. By early 1965, the Laguna Niguel Industrial Park employed people in six manufacturing plants. Additional firms had already committed to building within the industrial development within the next 18 months. (RNA.)

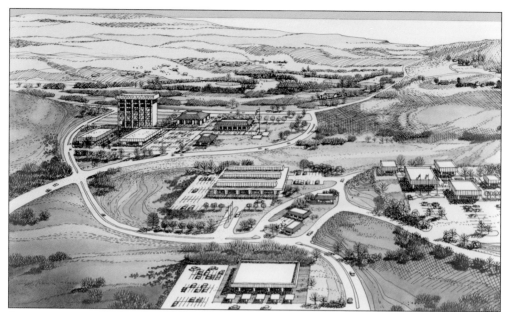

ARCHITECTURAL CONCEPTS OF TOWN CENTER, 1963. New studies and designs by Angelikis & Bailly for the revised town center began when the community layout and neighborhood adjustments were proposed for approval by the county. The central location within the ranch for the proposed town center was seen as ideal for Laguna Niguel residents. This portion of the site was to follow the original Gruen goals of what a town center should be for a community and its residents. (KFA and DPHS.)

ARCHITECTURAL MODELS OF TOWN CENTER, 1963. Some early architectural styles proposed for the town center through the 1960s looked at clean-lined design with some connection to Gruen's aesthetic choices. Gruen believed that the town center was perfectly located to serve Laguna Niguel. "The grouping of these elements," said Gruen, "produces a highly productive urban complex, with each element complementing the other and combining to achieve financial success and community acceptance." (KFA and DPHS.)

Three

A New Direction for the Master Plan

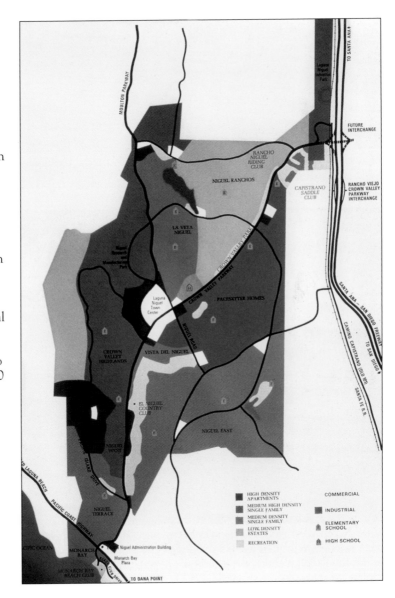

Revised General Plan, April 1963. The Orange County Planning Commission approved the first revision of the general plan for Laguna Niguel. The revised plans allowed the community to develop its population potential to 40,000, an increase of about 10,000 over the original plans. Several areas on the original plan were reduced, enlarged, or moved to new locations. The 10 planned residential communities were being developed within the master plan. A wide range of housing was to be available, tailored to a broad market, with house prices from $21,000 in Crown Valley Highlands to $185,000 in Niguel Ranchos starting in 1963. (RNA.)

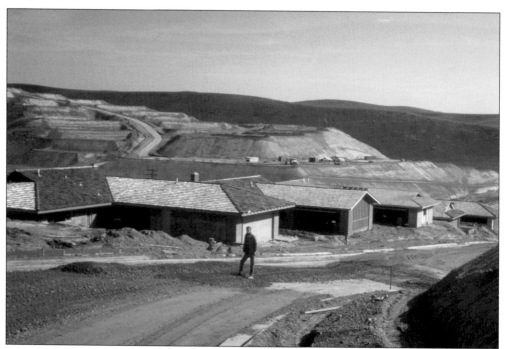

"EXCITING NEW BEACH AREA COMMUNITY," 1963. Pacesetter Homes purchased 1,100 acres in Laguna Niguel in July 1962 and planned to build 3,000 houses. Groundwork began in 1962 and construction at the site started in early 1963. (RNA.)

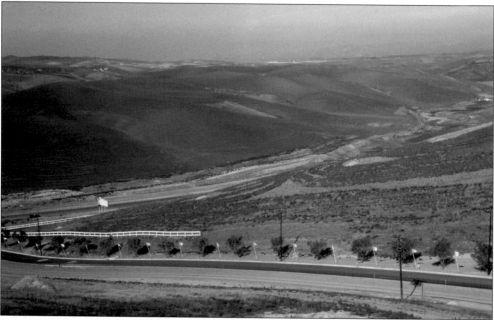

VIEW NORTHWEST FROM PACESETTER SITES, NOVEMBER 1963. In late 1962, work started onsite for what was originally planned as 3,000 Pacesetter Homes, projected at a budget of over $60 million at the time. Completion of the earliest 370 dwellings in the $20,000 price range was scheduled for late summer 1963. (KFA and DPHS.)

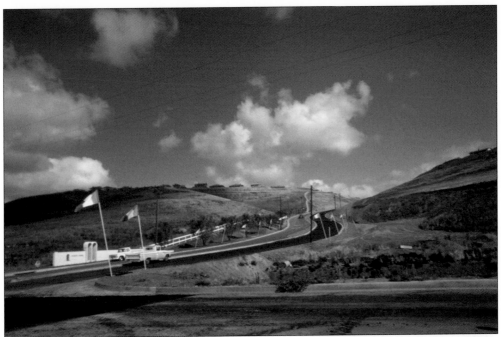

PACESETTER AT NIGUEL ROAD, MARCH 1964. The first 100 Pacesetter Homes, view lots on hillsides east of Crown Valley Parkway and north of Niguel Road, were sold in early 1963, months before there was anything to see but a project map and some blueprints. (KFA and DPHS.)

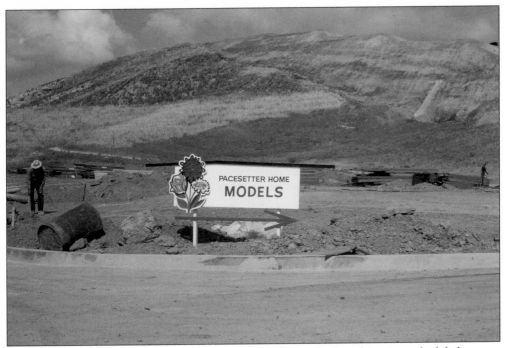

"A WONDERFUL WAY TO LIVE," 1963. The model homes for the first phase were scheduled to open in June 1963. To attract buyers, the builder noted that Laguna Niguel had been master-planned to establish a perfect balance of residential, commercial and recreational areas. (KFA and DPHS.)

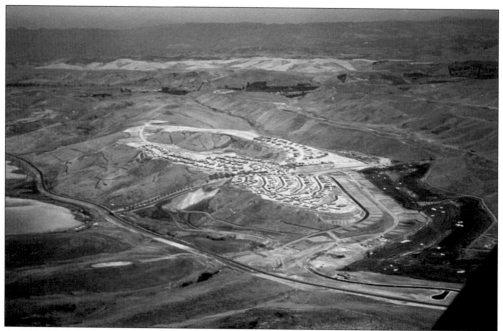

AERIAL VIEW OF PACESETTER HOMES, 1963. This view looking northwest shows the first sites for Pacesetter Homes on both sides of Niguel Road, east of Crown Valley Parkway. The single-loaded streets in the area at left provided unobstructed views from every house. The site north of Niguel Road included double-loaded, stepped streets, but the ridge-top location created views from both sides of the street. (RNA.)

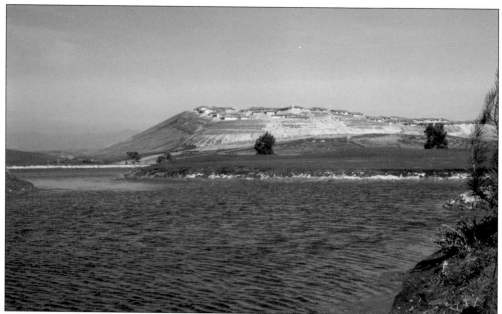

TERRACED LOTS WITH VALLEY AND OCEAN VIEWS, DECEMBER 1963. The homes overlooking El Niguel Country Club, high above the north end of the course, were on single-loaded streets. The boundaries of their large lots went from their front yard to the street below their backyard. (KFA and DPHS.)

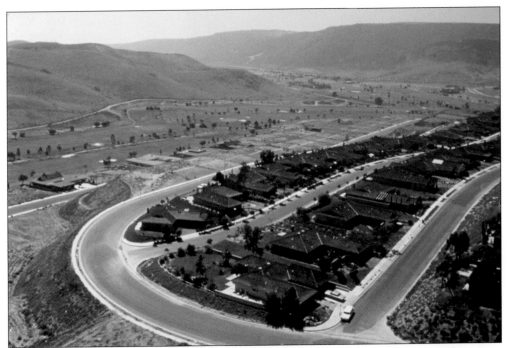

VIEWS FOR EVERY HOUSE. This neighborhood of terraced streets was part of the master plan. As in other neighborhoods, the empty lots on the leading edge of the site were for custom homes. This site grading followed the original contours, so each row of houses was high above the adjacent street behind the house; views were not blocked. (RNA.)

"HOME VALUES ARE PROTECTED," MARCH 1964. Pacesetter let buyers know when they visited the model homes that "home values are protected through master planning," which was an important part of unique development at that time. Many developers in other communities were simply building homes as fast and as low-cost as possible without a goal of longer-term value for the buyer. (KFA and DPHS.)

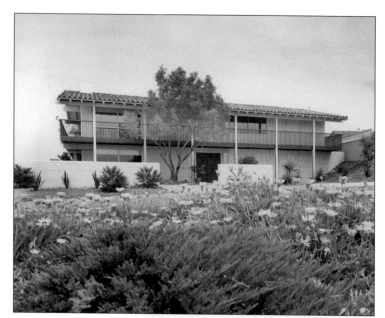

MONARCH BAY BECK HOUSE, 1963. Featuring the styling of Monterey and California ranch homes, this 4,400-square-foot house was featured in local and national newspaper and magazine articles starting in April 1963. It was the home of Bill Beck, vice president of the Cabot, Cabot & Forbes California office and of LNC Construction. (KFA and DPHS.)

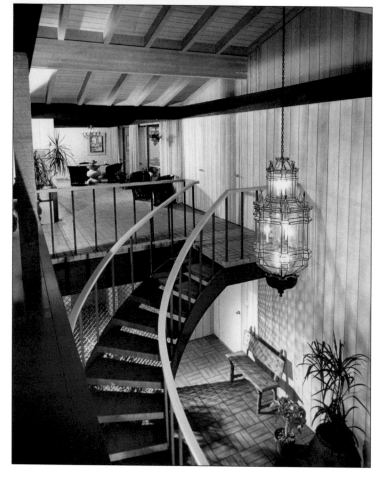

LOS ANGELES TIMES HOME MAGAZINE, APRIL 7, 1963. The Beck house was promoted as a "California" house, incorporating several design features of architecture associated with the history of the state. Selected materials, features, and layout combined a traditional home with a contemporary aesthetic. (KFA and DPHS.)

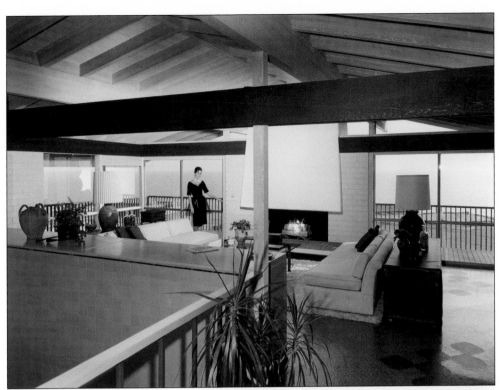

DESIGN TEAM, BECK HOUSE, 1963. Design and construction of the Beck house started in 1962. The house was built by LNC Construction, which was the building division of Laguna Niguel Corporation. Knowlton Fernald of Laguna Niguel Corporation was the architect, Gerald Jerome was the interior decorator, and Morgan Evans was the landscaper. Articles about the Beck house also included interior and exterior renderings from 1962 by Carlos Diniz. (KFA and DPHS.)

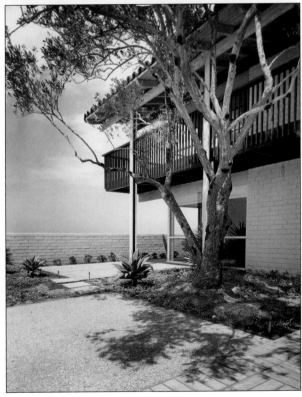

SYMBOL OF PAST, PRESENT, AND FUTURE, 1963. Planning this house included thorough exploration of the site and the desires, requirements, hobbies, and activities of its owners. The goal, as with any house designed in the early years for Laguna Niguel, was to encourage unique individuality and an understated beauty. (KFA.)

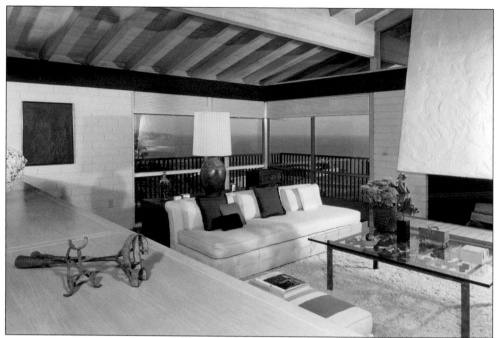

MEDIA COVERAGE, BECK HOUSE, 1963. *Ladies Home Journal* had an article on the Beck residence as one of the key houses in Laguna Niguel. The nation's top trade associations, services, and suppliers whose products and materials were used in constructing houses in the community featured the houses in nationally televised commercials throughout 1963 and 1964. (KFA and DPHS.)

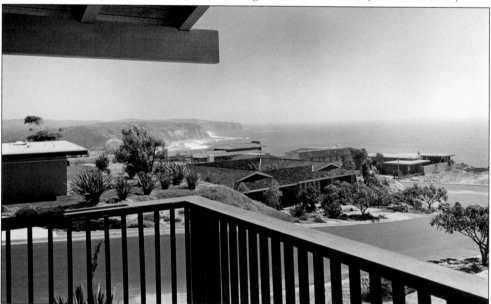

GRADING TO IMPROVE VIEWS, 1963. In order to gain level building space, the front half of the site facing the street was graded for the lower floor in half of the plan. The garage was built against the north slope, offering site support for the structure. These grading designs increased the garden area on the property and, by having the main floor of the house on the second level, the coastal view from the house was improved. (KFA.)

PATIO AND POOL, BECK HOUSE, 1963. The patio pool area features brick flooring that carries out from kitchen and the gallery to the entire area leading to the edge of the pool. The upper patio has a dining area, and the house features gas lights on the patio. (KFA and DPHS.)

CREATE UNIQUE CUSTOM HOUSES, 1963. Besides the tract development houses within Monarch Bay designed by Ladd & Kelsey, additional lots throughout the neighborhood were intermixed for custom homes by a variety of architects. Part of the reason for publicizing the Beck house was so that Laguna Niguel Corporation could sell custom lots throughout Laguna Niguel for houses designed by its architectural team and other noted architects. (KFA.)

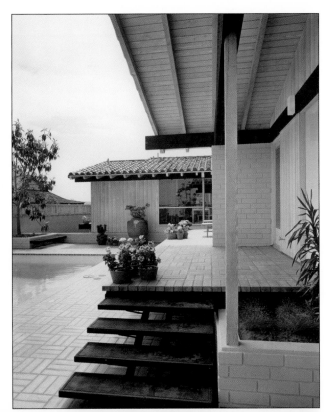

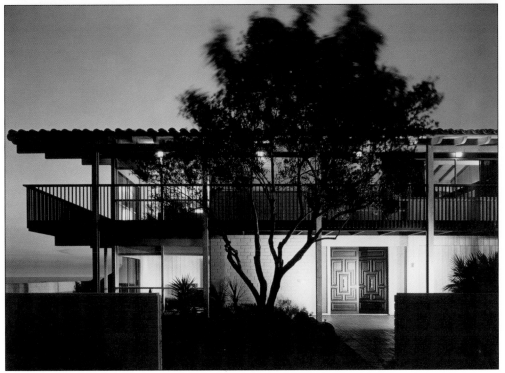

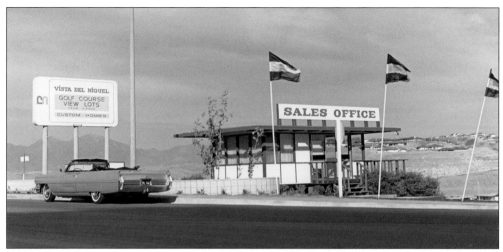

VISTA DEL NIGUEL SALES OFFICE, 1963. The original custom homesites abutting El Niguel County Club were Vista del Niguel, beginning in 1961. Starting in the late 1960s and up to the late 1970s, six additional developments—East Nine, West Nine, Westgreen, Greens East, Vista Niguel Estates, and Links Pointe—were built directly on the course. Additional neighborhoods abutting the course also offer hill and ocean views in El Niguel Heights and Foxboro Heights. (KFA and DPHS.)

VISTA DEL NIGUEL INFORMATION CENTER, 1963. In the sales office at Crown Valley Parkway and Paseo del Niguel overlooking the 18-hole private golf course, buyers could select large lots fronting the course with a minimum lot width of 90 feet. Noted architects then met with buyers to design their custom houses. (KFA and DPHS.)

NORTH VIEW FROM THE CLUBHOUSE, 1964. The two buildings to the right on the golf course are maintenance and landscaping facilities at the end of the driving range. This view from the El Niguel clubhouse also looks toward the new hilltop development between Hillhurst and Niguel Road. (RNA.)

PASEO DEL NIGUEL, MARCH 1964. North of the country club building is a new street partially completed in early 1964, built for custom home lots on the course. (KFA and DPHS.)

WEST VIEW FROM THE FAIRWAYS, MARCH 1964. The northern fairways of the course are east-west layouts. The house at far left, which was being completed, received widespread national attention focused on Laguna Niguel in 1964 when *House & Garden* magazine selected the 5,800-square-foot home on a fairway of El Niguel Golf Course as the ideal environment for "Our House of Ideas." Architect Fred Briggs designed the house, open to the public from July to September. (KFA and DPHS.)

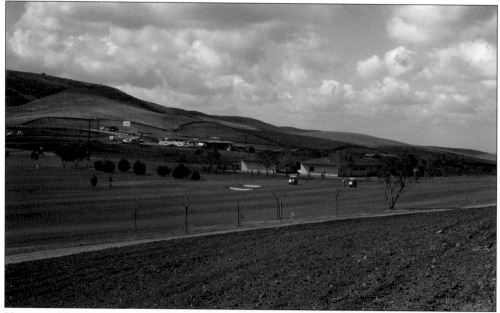

VISTA DEL NIGUEL LOTS AND "OUR HOUSE OF IDEAS," MARCH 1964. The custom home lot sales information center, at left near the signage, was also the entry point for the upcoming *House & Garden* magazine "Our House of Ideas" home tour. The two larger structures in the middle of the golf course are the maintenance and landscaping facilities. (KFA and DPHS.)

HOUSE & GARDEN'S OUR HOUSE OF IDEAS FOR 1964. The house was noted as a striking composition of shapes and textures, light and shadow, and "virtually a self-contained environment, wonderfully varied and full of delight. . . . An arresting profile, inviting textures." Over 250 companies cooperated with *House & Garden* in designing, constructing, and supplying building materials, equipment, appliances, furniture, lighting, landscaping, and accessories throughout the house and garden. (KFA.)

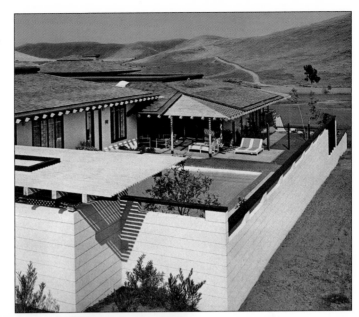

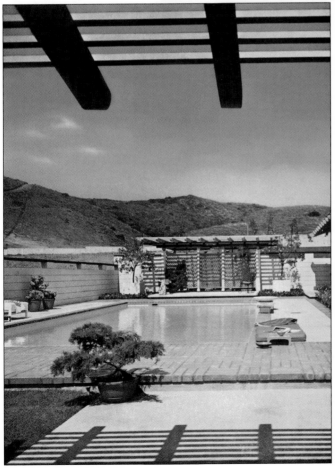

"MAGICAL INTERPLAY OF LIGHT AND SHADE," AUGUST 1964. All over the house, light and shadow cast varied changing patterns. At one end of the pool, a raftered, lattice-screened enclosure concealed the pool's mechanical equipment and "projects a veritable filigree of shadow." A bolder pattern was produced at the other end by one of the many open rafter sections in the roof of the house itself. The article called Laguna Niguel "a wonderful new kind of town. . . . As you drive through Laguna Niguel today, the benefits of a superb master plan are already manifest." (KFA.)

101

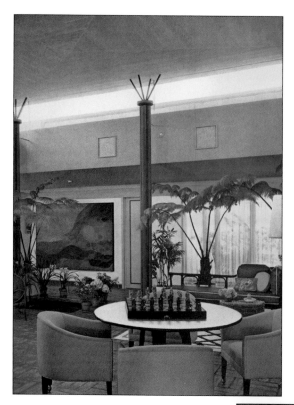

**"EXHILARATING GARDEN ROOM,"
AUGUST 1964.** Featured on the cover
and throughout the magazine in the
annual national house selection by
Home & Garden magazine, the house
facing the golf course reflected the
heritage of the area in its modern
architectural design. The 32-by-27-
foot interior central garden room rises
to a height of 13 and a half feet and
"is crowned with a continuous band
of glass . . . and the sun streams in
all day long." Eight wood columns
topped by metal fingers that suggest
tree branches support the inverted
pyramid shape of the ceiling and
roof above. (Author's collection.)

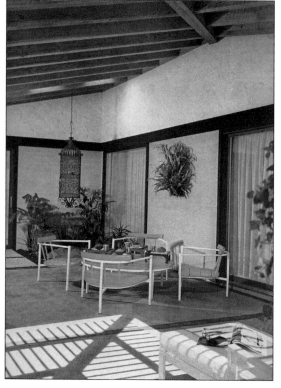

**"ENTICING OUTDOOR AREAS," AUGUST
1964.** The inner end of this outdoor
room is sheltered by the roof, with
skylights along the wall over the
sliding doors, windows, and plantings.
The outer end of the roof is open
rafters, and sunlight creates a pattern
throughout the patio. The magazine
featured another article explaining
the overall master plan of Laguna
Niguel and how, throughout America,
design standards, landscaping, and
social connections could create better
ways to live. (Author's collection.)

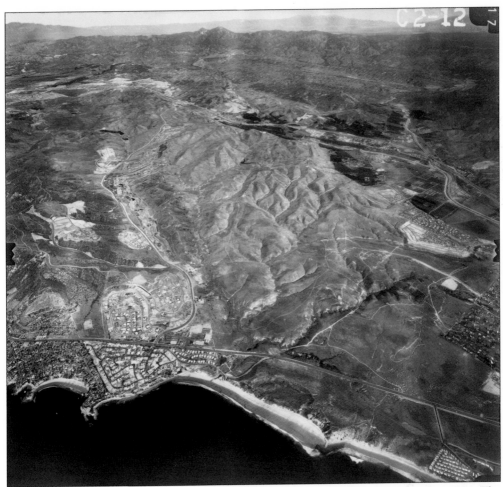

Aerial Image, 1965. The building activity throughout Laguna Niguel increased in 1964. The progress of the earliest concepts and actual development was described in architectural journals in Germany, France, and South America. Laguna Niguel Corporation positioned the community as "The Ultimate in Coast and Country Living." View lots and golf course frontage were available for custom homes, and architect-designed development houses that had already won national recognition and awards were also available. The connection of Crown Valley Parkway between Coast Highway and the San Diego Freeway allowed for planned neighborhoods that increased the market audience for the community. This image was photographed as the discussions began for acquiring the additional large properties south along the coastline and inland to the existing southeastern master plan boundaries. (Author's collection.)

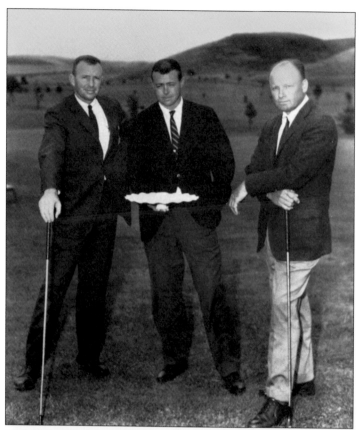

HORIZON HOME ANNOUNCEMENT, 1963. The planning and initial grading of the Niguel West neighborhood began in 1962. From left to right, structural engineer Hanns Baumann, architect George Bissell, and builder Morris Goodman are at El Niguel Country Club with a model of the concrete Horizon Home to be built overlooking the golf course in the Niguel West neighborhood. (Author's collection.)

The home is basically a combination precast and cast-in-place concrete "mushroom" of unsurpassed strength and stability. Fire, weather and termite-resistant, it is a major step forward in the development of mini-mum-maintenance housing as well as a satisfying esthetic achievement.

PARTICIPANTS: Furnishings by Frank Bros. Furniture Co. • Decorating by Barbara Millier • Landscaping by M. Purkiss & Assoc., Landscape Architects • Construction by the Laguna Company • Concrete by Livingston-Graham, Inc. • Orco Block and Artlo Cast Stone Co. The Concrete Industries Horizon Homes Program in its fourth year is sponsored jointly by the Portland Cement Association, National Ready-Mixed Concrete Association, National Concrete Masonry Association, Prestressed Concrete Institute, and Asbestos Cement Products Association.

HORIZON HOME BROCHURE, 1964. This home is a combination of precast and cast-in-place concrete. The strong, stable, mushroom-shaped structure is also fire, weather, and termite-resistant. Not only did this design create open glass exterior walls, it also allowed minimum maintenance and unobstructed views. (Author's collection.)

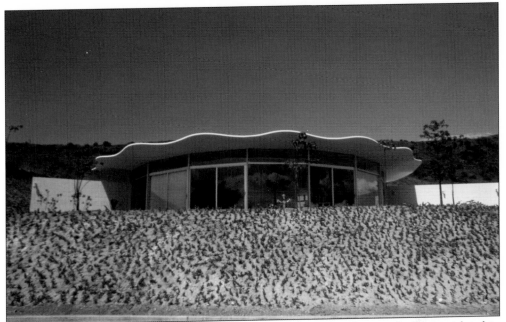

CONCRETE INDUSTRIES HORIZON HOMES PROGRAM, MARCH 1964. This circular house with a thin shell concrete roof and glass walls was built and opened to the public beginning April 25, 1964, as part of the nationwide program. More than 125 unique modern concrete Horizon Homes had been exhibited across the nation from the start of the program in 1960 to 1964. (KFA and DPHS.)

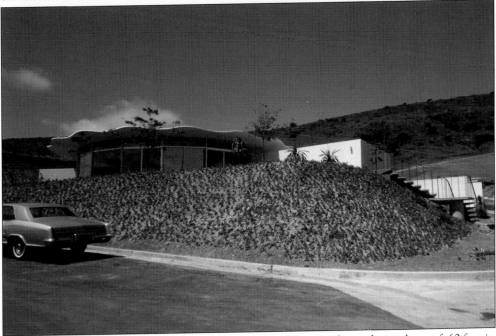

LAGUNA NIGUEL HORIZON HOME, MARCH 1964. The fully cantilevered, circular roof, 60 feet in diameter, rises from an eight-foot-wide curved concrete core. The central core not only supports the entire weight of the roof but also contains the utilities for the house, plus the fireplace and bathroom shower. (KFA and DPHS.)

HORIZON HOME ENTRY, MARCH 1964. Space between the upper and lower cantilevered concrete roof layers is used as open ducting to provide heating and airflow throughout the 2,000-square-foot house. The concrete floor throughout the house is highlighted by exposed aggregate using large black beach pebbles. (KFA and DPHS.)

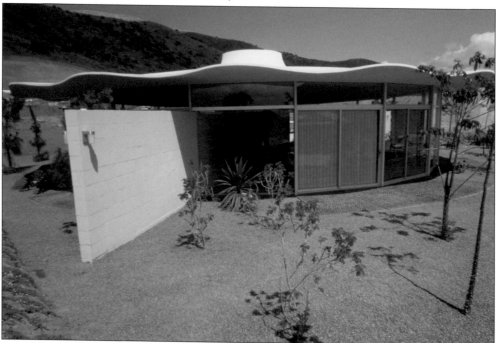

TRANSOM GLASS AND EXTENDED WALLS, 1964. At the Horizon Home, three non-load-bearing masonry walls radiate from the center, below the roof, and extend into the outside garden, penetrating the entire glass perimeter. The undulating edges of the concrete roof extend six feet beyond the glass walls on all sides. (KFA and DPHS.)

106

NIGUEL WEST MODEL HOMES, 1964. Single-level and two-level houses throughout the neighborhood were pre-sold beginning in 1963, before the model homes opened. Architect George Bissell designed over 200 houses planned for Niguel West. (KFA and DPHS.)

UNPARALLELED ADVANCES IN MODERN DESIGN, 1964. The homes in Niguel West are similar designs in many ways to Monarch Bay and Niguel Terrace: flat and peaked roofs, post-and-beam structures, full glass facades, large private entry courtyards, and unobstructed views. (KFA and DPHS.)

Niguel West: High Standards of Design. The main living rooms in single- and two-level houses offer views of the golf course to the east, the ocean to the south, and hills to the north, and always have inward views to the private courtyard and expansive adjoining natural terrain slopes that are part of the neighborhood. The atrium plans wrap the house around a central outdoor space. Many of the street-facing walls of the single-floor houses are private, with few windows. In the interior, many rooms open into the central courtyard, often with a slim-columned portico and cantilevered roofs around the exterior walls, giving shade and protection from rain. In the two-level houses, the main living areas, kitchen, and bedrooms are on the upper floor, providing unobstructed, private views from the front of the house. The sites for the two-level plans are step-graded so the upper floor has access to the backyard. (KFA and DPHS.)

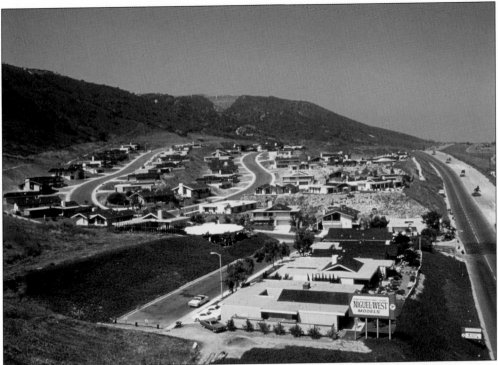

NIGUEL WEST SINGLE-LEVEL HOUSES, 1964. Enclosed courtyard facades face the street, while full glass walls throughout the house allow access to the large private front and back gardens and provide unobstructed distant views. (KFA and DPHS.)

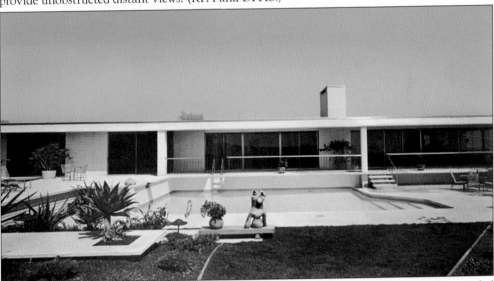

"HOUSE OF EXCELLENCE," NIGUEL TERRACE, 1964. Architect John Galbraith originally intended this house to be part of the Horizon Home program, but he used concrete and teamed with a stainless steel corporation for another house built by Laguna Niguel Corporation. This house, named Olympia Pacifica, established two basic goals according to Galbraith: flexibility and permanence. He also noted that "residential design calls for greater discipline than it has received." (Author's collection.)

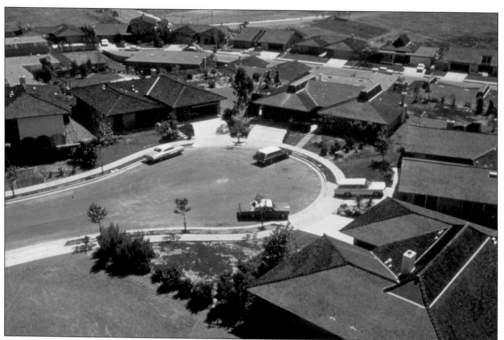

LA VETA NIGUEL, 1964. In October 1963, Laguna Niguel Corporation announced the sale to the Smyth Brothers of approximately 500 acres north of Niguel Road, east of Alicia Parkway, and west of Crown Valley Parkway, continuing west of the upcoming community and regional parks. The sales brochure noted that "there is a personality born out of the desire of architect and builder to create homes that are distinctive, unique, and highly individual." (KFA.)

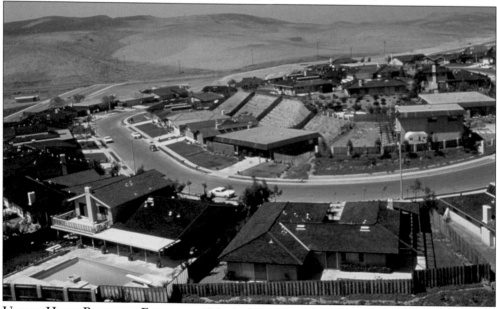

UNIQUE HOUSE PLANS AND EXTERIORS, 1964. La Veta Niguel had views in all directions within the central portion of Laguna Niguel. The architectural firm Thomas and Richardson, AIA, designed the houses. Eventually, Smyth sold the northern portion of the neighborhood to S&S Construction—David and Nathan Shapell—who built the Kite Hill neighborhood there. (RNA.)

RANCHO NIGUEL RIDING CLUB, MARCH 1964. Residents could house their horses at the stables and also rent a horse every day from 10:00 a.m. to 5:00 p.m. "Rancho Niguel Riding Club has full facilities for taking advantage of the miles of riding trails which have been established throughout the area," the *Los Angeles Times Home* magazine reported on August 3, 1963. (KFA.)

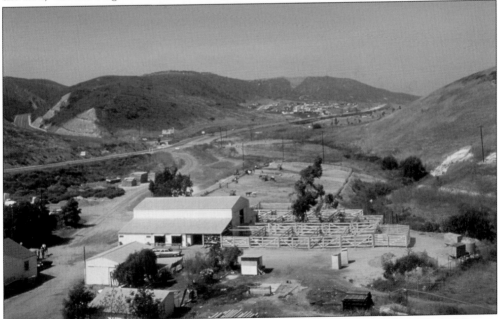

VIEW NORTH FROM THE RIDING CLUB, 1965. The riding club offered daily instruction in Western and English riding. The trails were planned to one day link into the statewide trail system in the Cleveland National Forest. This view shows distant Niguel West houses, an uphill street between the hills, and at left, Pacific Island Village. (KFA.)

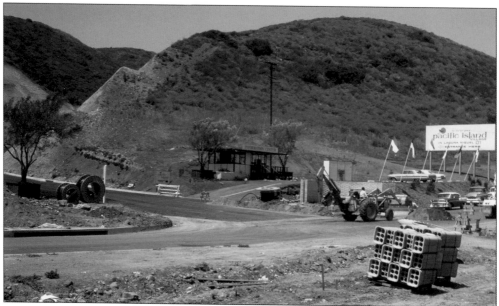

Pacific Island Village Information Center, May 1964. At the northwest corner of Crown Valley Parkway and Pacific Island Drive was the information center for the adults-only community—"For the Fun Years"—at the top of the highest hill in Laguna Niguel. The planned single-level houses offered privacy, hilltop and park-connected walking paths, and expansive views broader than any in south Orange County. (KFA and DPHS.)

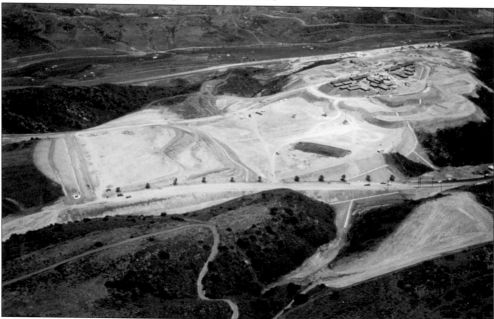

Pacific Island Grading at Hilltop, 1964. Pacific Island Village's 111 homes were the first phase of the neighborhood in 1964. Grading and construction had started a year earlier. The original plan was to eventually have 700 residences, a neighborhood shopping center, a church, and the Pacific Island Club, a private membership club with recreation, dining, and other facilities. (KFA and DPHS.)

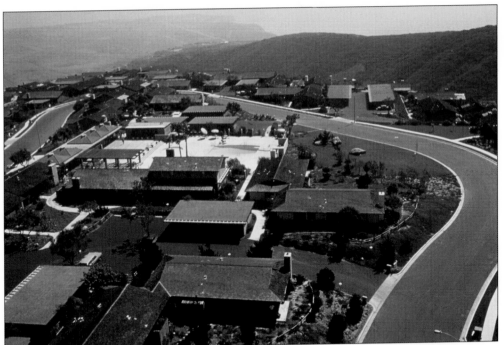

PACIFIC ISLAND VILLAGE PANORAMIC VIEWS, 1965. The name "Pacific Island" was chosen because the 900-foot-tall hilltop was a prehistoric island in the Pacific Ocean. Much of the property is sandy and has large water-worn seaside rocks. Some of the adjacent hilltop area has been preserved as Badlands Park and Trail, with panoramic ocean views from Palos Verdes to San Diego. (KFA and DPHS.)

PACIFIC ISLAND VILLAGE RECREATION AND SOCIAL CENTER, 1965. Families with children 18 years of age and older were allowed to purchase homes at Pacific Island Village. Included in the initial 35-acre portion of the adult community was a dance pavilion, picnic area, large swimming pool, patio, and barbecue area. (KFA and DPHS.)

El Niguel Country Club Houses, 1965. On the north side of the golf course fairways, wide lots along a slightly sloping, single-loaded street have unobstructed views of the course and hillsides. The custom house for Mary Ellen Evans Christianson's family was one of the earliest houses built on Paseo del Campo. (MECC.)

Connection to Nature along El Niguel, 1965. The earliest original houses built throughout Laguna Niguel offered courtyard privacy and solid walls on the street side. Houses on the golf course featured large glass walls and an open backyard garden, plus expansive views of the valleys and hillsides. All houses along the northwest and northern boundaries of the course north of Club House Drive were custom. These fairways were originally the front nine. (MECC.)

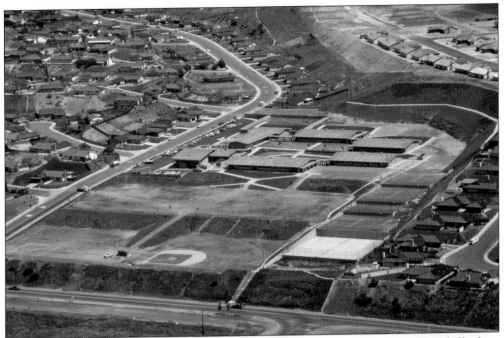

CROWN VALLEY ELEMENTARY SCHOOL. Construction started in the spring of 1965 on a hilly, four-level, 17-acre site east of Crown Valley Parkway within the later Pacesetter neighborhoods. This was the first elementary school in Laguna Niguel. As was originally planned, approximately 22 percent of the population in Laguna Niguel are of school age. (RNA.)

CROWN VALLEY ELEMENTARY SCHOOL, FEBRUARY 1966. Land was originally reserved for 12 more elementary schools and one high school in Laguna Niguel. Another high school, Dana Hills High School in Dana Point, was planned for students in the southern part of Laguna Niguel and opened in 1973. (RNA.)

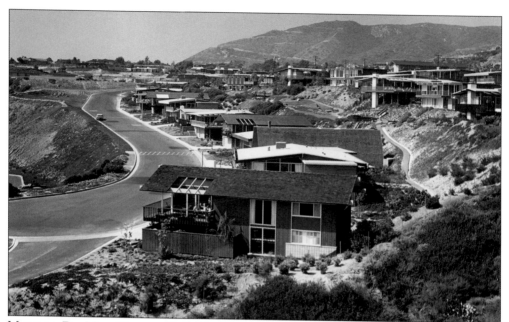

MONARCH BAY MALL HOUSES, 1965. The neighborhood was an 11-acre development of 44 houses directly southeast of the Monarch Bay houses and lots. This project was designed so that each house had a dramatic view of the ocean, the luxury and beauty of open landscape space, and privacy without the closing of drapes, according to contemporary articles. (RNA.)

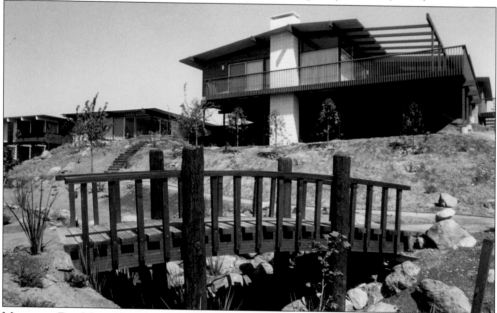

MONARCH BAY MALL, CONCEPT AND SOLUTION, 1965. The project was conceptually designed in 1962 with a preliminary planned completion in September 1963. It was referred to as Monarch Bay II in the initial concept plans and drawings. The architects' early presentation study stated, "The design solution for Monarch Bay II is not intended to be a solution for any situation, but rather a specific solution for a certain piece of property and set of circumstances and a proving ground for ideas." The houses were completed in 1965. (KFA and DPHS.)

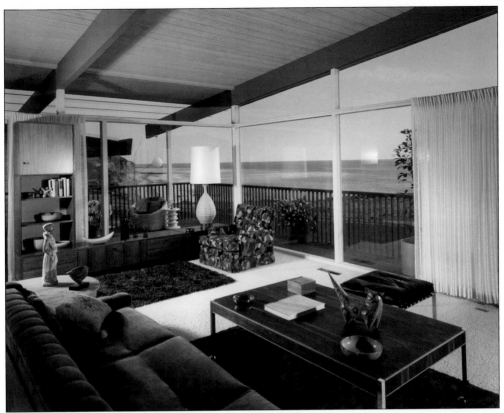

MONARCH BAY MALL ARCHITECTURE AWARD, 1965. The Laguna Niguel Corporation architects—Knowlton Fernald Jr., Ricardo Nicol, and Arthur Schiller—received the 1966 Award of Merit from the American Institute of Architects for the Monarch Bay Mall project. (KFA and DPHS.)

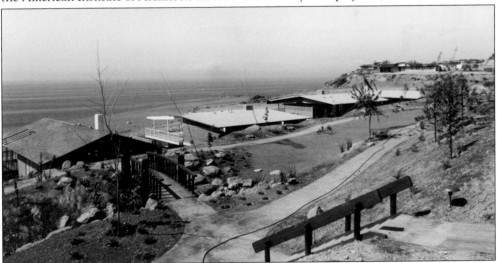

MONARCH BAY MALL OPEN VIEWS, 1965. Among the 44 houses, all of the landscape was open space, maintained by the community association. Fencing was not allowed, and each house was designed so as to open visually on three sides. The fourth side became the "visual fence" for each house that overlooked another house with privacy by means of a grade separation. (RNA.)

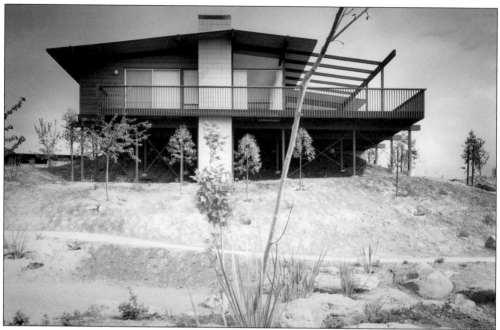

MONARCH BAY MALL SITE GRADING, 1965. To produce a more flowing natural final grading in the neighborhood, several of the houses were designed to be built with only about 50 percent of the floor area enclosed by the foundation walls. The rest of the house was built on wood posts and isolated footings so that the grade can slope smoothly away from the house. (KFA and DPHS.)

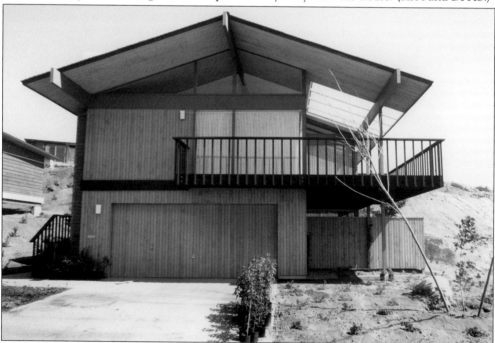

SINGLE- AND MULTI-LEVEL HOUSES, 1965. Some of the houses have split levels, and the grade change occurs with a retaining wall in the middle of the lot. In full two-level houses, some have a smaller lower floor, which permits a grade change under the house. (KFA and DPHS.)

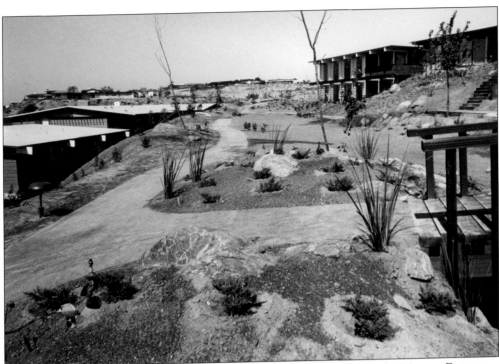

MONARCH BAY MALL LANDSCAPE PATHS, 1965. The landscape design by Morgan Evans was continuous throughout the neighborhood rather than individual lots. Walks, steps, and plazas were produced in brick, pebble concrete, and gravel. (RNA.)

MONARCH BAY MALL PLANTINGS AND PATHS, 1965. Low retaining walls were to be mostly built of surplus materials such as broken concrete, railroad ties, and telephone pole sections. The greenbelt was lawn surrounded by native and semi-native trees, shrubs, and ground cover. (KFA and DPHS.)

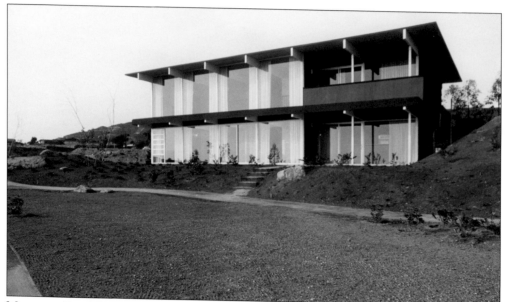

MONARCH BAY MALL BEACH ACCESS, 1965. Each house at Monarch Bay Mall has an ocean view, access to the common green, and a path to the beach. The eight floor plans offered several configurations of rooms. The original designs were two- and three-bedroom houses from 1,765 square feet to 2,210 square feet. (KFA and DPHS.)

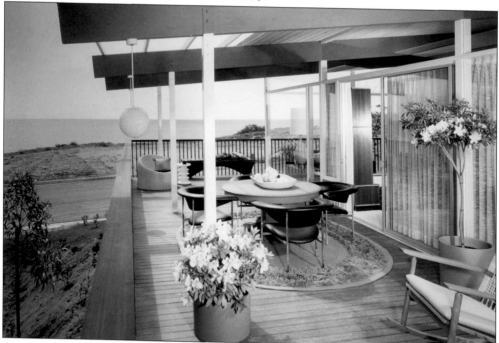

CONSISTENCY AND DIVERSIFICATION, 1965. For Monarch Bay Mall houses, there were no alternate exterior elevations. The diversification in the group of 44 houses was accomplished by using more plans than normal and through variations in site development and landscaping. This consistency improved the views from each house and also created privacy among very open, modern house designs. (KFA and DPHS.)

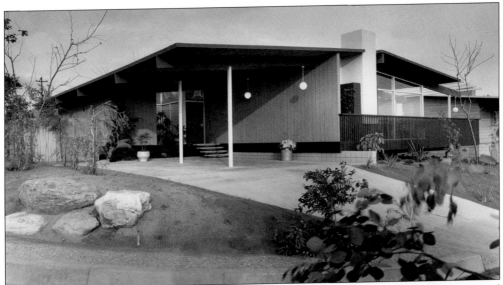

DESIGN AND DETAIL THROUGHOUT LAGUNA NIGUEL, 1965. The Monarch Bay Mall design and detailing was also found in other houses throughout Laguna Niguel. Shingle siding and pre-stained, re-sawn cedar siding of various details were used for the entire exteriors and certain interior walls. Sloped and flat roofs, clerestory glass, square-patterned concrete block, and modern exterior lamp fixtures were part of the architectural standards in the community. (KFA and DPHS.)

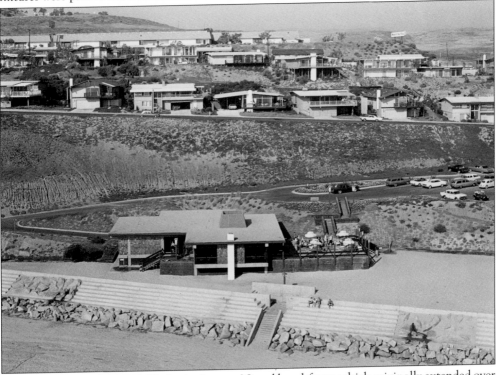

MONARCH BEACH CLUB, 1965. At the Laguna Niguel beachfront, which originally extended over 1,000 feet of white sand, the clubhouse site was sheltered from northerly and westerly winds by the terraced banks where the Monarch Bay Mall homes were sited. (KFA and DPHS.)

121

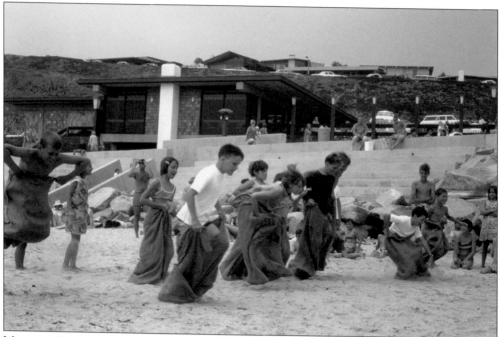

MONARCH BEACH CLUB IN LAGUNA NIGUEL. A single-level portion of the design was completed in 1965. The building was designed so a second floor could be added in the future. The gradually sloping shoreline of rocks, soil, and sand along the beach provided what was referred to in various articles as one of California's safest beaches. (KFA and DPHS.)

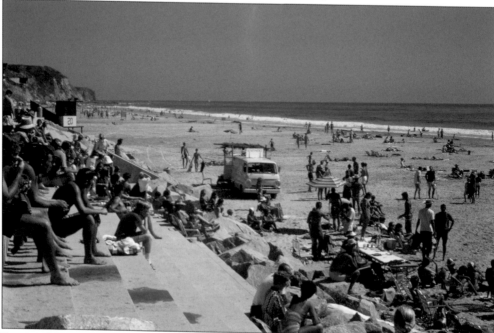

LAGUNA NIGUEL OCEANFRONT EVENTS. Residents throughout the entire community could visit the private beach club. Regular community activities, such as this 1968 Fourth of July celebration, were popular. (KFA and DPHS.)

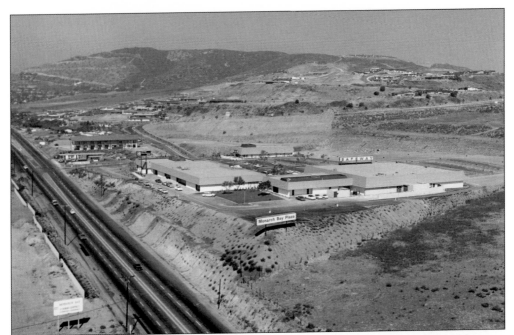

MONARCH BAY PLAZA, 1965. The 11-acre shopping center featured approximately 76,000 square feet of retail space. Laguna Niguel Corporation architect Ricardo Nicol planned the center in a modern Mediterranean-style plaza concept with uncluttered exterior designs, natural landscaping, and arcades. (KFA and DPHS.)

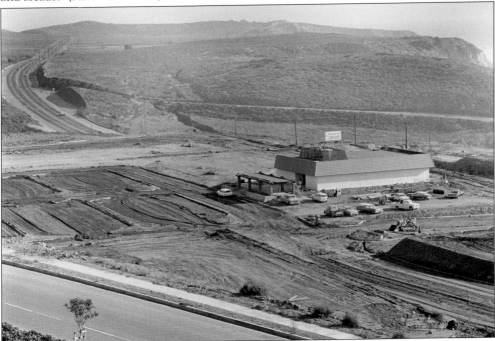

EARLIEST CONSTRUCTION, MONARCH BAY PLAZA, 1964. The first building constructed as part of the plaza was for United California Bank. This was built using different construction methods than the retail areas to offer some level of protection for the bank. (KFA.)

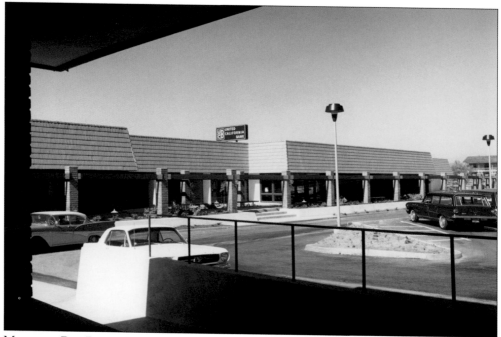

MONARCH BAY PLAZA BANK, 1965. In early February 1965, United California Bank's Laguna Niguel location opened. The other retail stores in the plaza opened throughout 1965. (KFA and DPHS.)

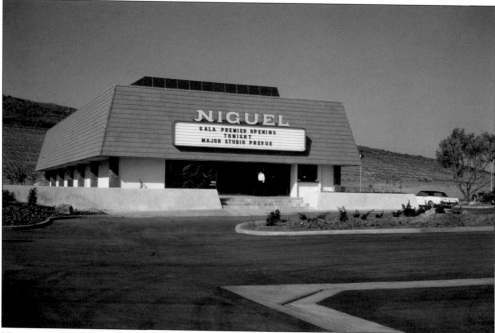

NIGUEL THEATER, MONARCH BAY PLAZA, 1965. The theater opened on June 9 with the major studio preview gala benefit of the movie *Shenandoah*, starring James Stewart, Doug McClure, Glenn Corbett, Patrick Wayne, Rosemary Forsyth, Philip Alford, and Katherine Ross. (KFA and DPHS.)

MONARCH BAY PROFESSIONAL BUILDING, 1965. The office building at 3 Monarch Bay Plaza was completed in 1966. It is located west of Monarch Bay Plaza and housed Laguna Federal Saving and Loan Association, insurance and professional offices, some Laguna Niguel Corporation staff, and later, offices of Avco Community Developer, which became the developer of Laguna Niguel in 1971. (KFA and DPHS.)

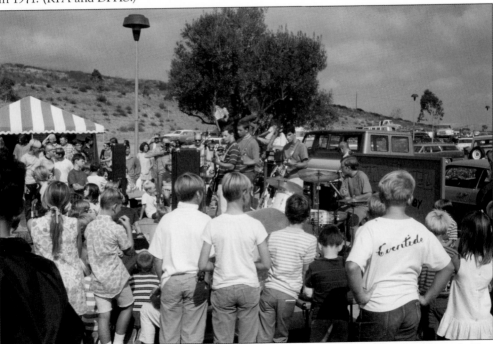

ANNUAL FIESTA DEL NIGUEL, 1969. The annual Fiesta del Niguel, starting in 1967, was held at Monarch Bay Plaza and organized by the Laguna Niguel Community Coordinating Council. It was a community-based activity, with nearly every service club and community organization taking part in the event through the operation of 20 food and game booths and a beachfront fireworks show. (KFA and DPHS.)

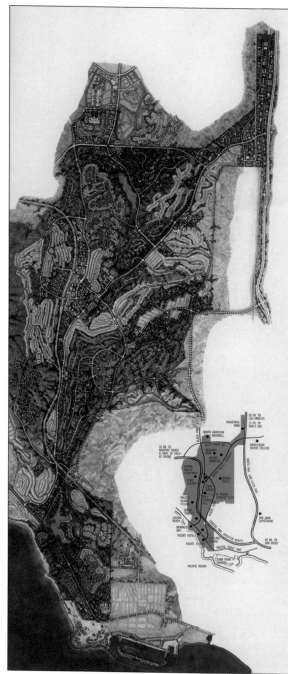

LAGUNA NIGUEL
by the Seashore

A Triumph
of Masterful Planning

There is no master-planned community in
America to equal Laguna Niguel
in its natural diversity of land
and water and its excellence of present
and long range usage. All that is good
in modern technology, construction,
conservation, transportation, economics,
land improvement and the social sciences
is being applied here.
The merits of building according to the
present and future needs of people
already are evident in Laguna Niguel.
It's the finest example of planning;
an entire New Town, complete with industry,
full-range civic services, schools, churches,
internal road net and freeway interchanges,
major shopping and commerce, a true
industrial base, its own ocean shoreline,
inland lakes, recreational areas and facilities
and superb residential housing available
in a wide spectrum of location and price.

All of these worthwhile elements are so
rarely found that, taken together, it's difficult
to measure their value to each Laguna Niguel
resident. Their true significance emerges when
your home is here. You'll find your family
experiencing a whole new life style.

Laguna Niguel's master plan means a better
life today and for all the years to come.

FREEWAY OPPOSITION, 1965–1967. By early 1965, Laguna Niguel Corporation projected a population that could easily reach over 50,000 in the upcoming years. In late 1967, the controversial freeway route that the state had proposed to cut through the entire community of Laguna Niguel was eliminated. This freeway proposal, started in 1965, had hampered house sales and property sales to developers within the community for two years. Laguna Niguel residents within the valley had led the opposition against this freeway proposal and were successful in their efforts to save the community. (LLA.)

126

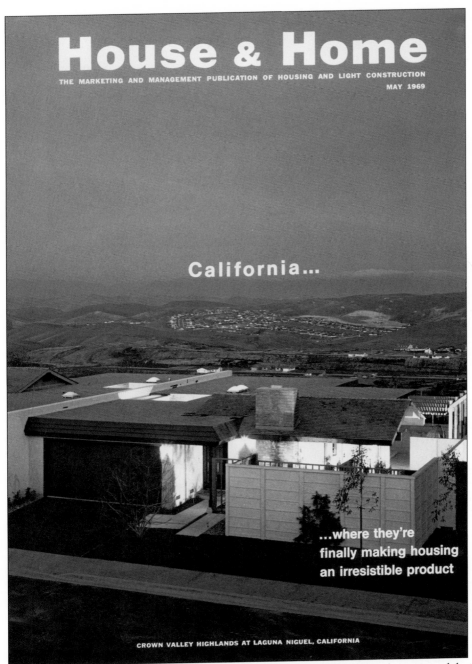

House & Home

THE MARKETING AND MANAGEMENT PUBLICATION OF HOUSING AND LIGHT CONSTRUCTION

MAY 1969

California...

...where they're
finally making housing
an irresistible product

CROWN VALLEY HIGHLANDS AT LAGUNA NIGUEL, CALIFORNIA

CROWN VALLEY HIGHLANDS, HOUSE & HOME, MAY 1969. The original site planning and design started in 1965. Site construction started in 1967. Crown Valley Highlands was a 1,300-acre zoned planned community. It was to include two elementary schools, two churches, and 2,000 housing units of varying configurations: single-family homes, patio homes, and town houses. According to the publication pictured here, Highlands provided "maximum privacy, convenience, and comfort—both inside and out" through the new concept of "garden lot" use. The community planning also included recreational areas, numerous greenbelts, landscaping, and winding pathways throughout the hillside development. (Author's collection.)

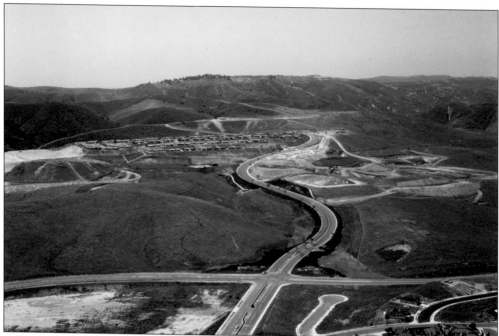

CROWN VALLEY HIGHLANDS, 1969. The goal in making these homes appealing was to offer extraordinary views and privacy on a wide hilltop location. Marketing was planned to attract younger homeowners so that long-term residents could join the community early. (RNA.)

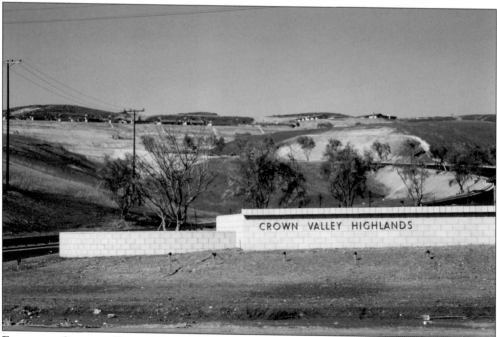

ENTRANCE SIGNAGE, DECEMBER 1968. This style of entry signage was planned for the entire community since 1960. At Alicia Parkway, these walls and olive trees flanked both sides of Niguel Road. (RNA.)

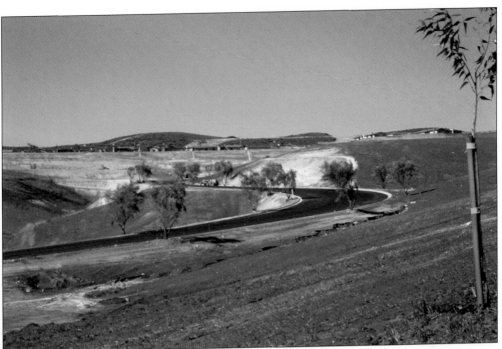

ENTRY DRIVE, CROWN VALLEY HIGHLANDS, DECEMBER 1968. Niguel Road is a curving access path that follows the natural contours of the hillsides. On Sunday, January 19, 1969, Crown Valley Highlands' eight single-level model homes opened to the public, but pre-sales had already occurred. (RNA.)

THE HIGHLANDS ENTRANCE SIGNAGE, 1972. When Avco Community Developers became the new master developer of Laguna Niguel in 1971, the graphic design within the community changed to a more consistent plan. (RNA.)

GRADING OF CROWN VALLEY RECREATIONAL PARK, 1967. The goals were to provide a very wide range of recreational possibilities for the residents, add beauty and preservation of the existing native slope areas, and create safe and direct pedestrian circulation to schools, churches, shopping, and recreation throughout the entire community. (RNA.)

CROWN VALLEY HIGHLANDS RECREATIONAL FACILITY, 1969. Crown Valley Highlands has a large recreational facility site that includes a clubhouse, meeting room, event space, patios, swimming pool, sports field, and playground. Residents are also entitled to beach club privileges at the community's coastline. (RNA.)

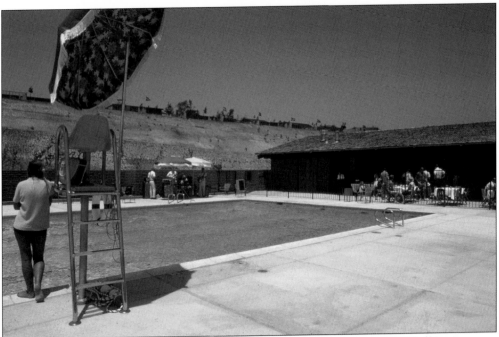

RECREATIONAL FACILITY SWIMMING POOL, 1969. A goal within Crown Valley Highlands was to provide activities for children. For adults, the sales advertisements for Crown Valley Highlands noted that the neighborhood was "just four minutes from North American Rockwell." (RNA.)

BRIDGE SPANNING NIGUEL ROAD, 1969. This bridge provided access from the second phase planned for the neighborhood. Throughout Crown Valley Highlands, public paths for walking, hiking, biking, and horseback riding were planned in an integrated landscape. The same architects first built similar paths on a small scale as an experimental test among the homes at Monarch Bay Mall in Laguna Niguel. (RNA.)

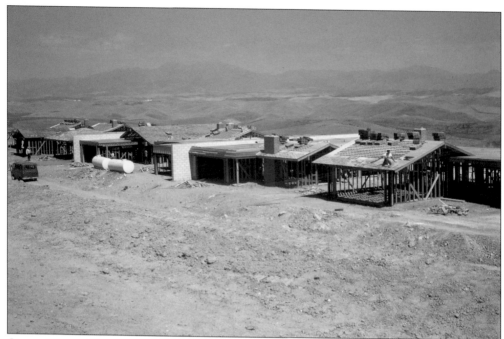

CROWN VALLEY HIGHLANDS CONSTRUCTION, 1968. Laguna Niguel planners laid out the homesites in a series of single-loaded terraces, which had been part of the master plan throughout the entire community of Laguna Niguel. The homes front on level streets, and all the streets are on different levels steep enough to provide unobstructed views from all homes. (RNA.)

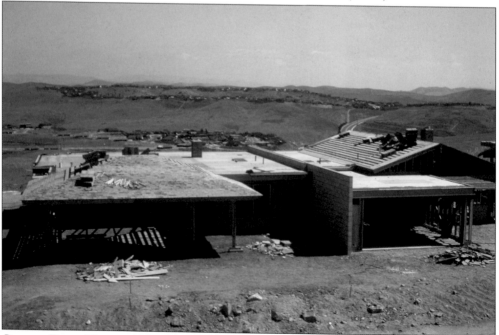

GARDEN PATIO HOMES, 1968. The "garden home" concept allows three-sided yards with the house placed on the lot line, which gives residents the family advantages of privacy and indoor-outdoor living. (RNA.)

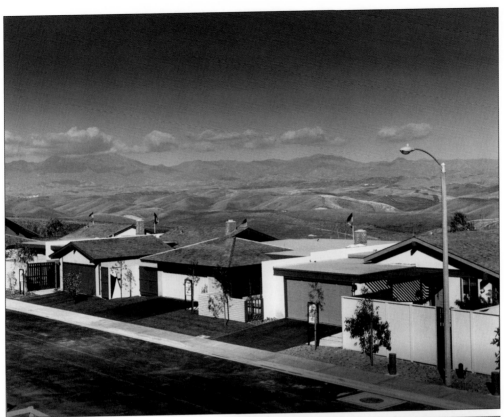

CROWN VALLEY HIGHLANDS MODEL HOMES, 1969. The streetscaping goal was to create a clean and uncluttered look throughout the community. The single-loaded street transitions from various levels are fully landscaped, and the front courtyard fences of the houses are close to the street. Each home was to have an unobstructed view of the surrounding, gently rolling terrain. (RNA.)

SOUNDPROOF DUAL CONCRETE COMMON WALLS, 1969. The houses are set on one side of the property line, which provided at least a 10-foot side yard on the other side. Two houses are backed up on every other property line, using two masonry walls separated by a one-inch air space to provide sound and visual privacy. (RNA.)

BOATS, TRAILERS, CAMPERS, STORAGE AREA, 1969. Eight-foot-wide gates in the front courtyards at Crown Valley Highlands provide access to private storage space for residents' boats, trailers, and campers. This also enhances the overall appearance of the community by screening such items from public and private views. (RNA.)

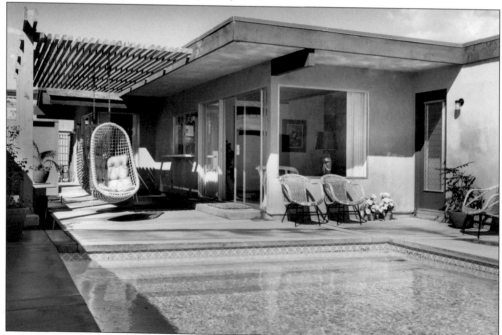

PRIVATE VIEWS GARDENS, 1969. In Crown Valley Highlands, the homes feature a side yard garden-patio twice the width of average side yards due to the "common wall" layout. The front yards are also completely enclosed, creating a private, atrium-like garden. (RNA.)

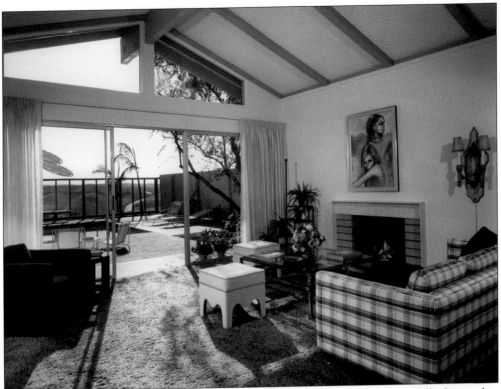

HILLSIDE VIEWS, CROWN VALLEY HIGHLANDS, 1969. The development was carefully designed to provide a view from the rear of every lot, safe and convenient level streets with short sloping transitions connecting streets, and, as throughout all of Laguna Niguel, underground utilities. (RNA.)

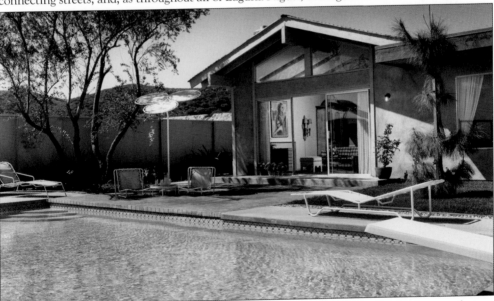

WIDE HILLTOP GARDENS, 1969. The gardens at the back of the houses offer unobstructed views of hillsides, valleys, and distant mountains. The front, side, and rear garden areas connect to three sides of the houses through sliding glass doors. (RNA.)

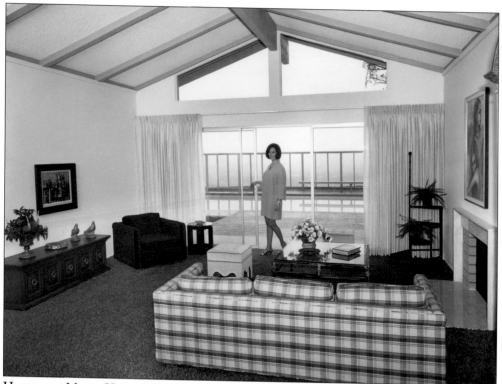

HIGHLANDS MODEL HOME, 1969. The sales brochure for Crown Valley Highlands—with exterior elevations, floor plans, and photographs—named the model homes after upscale beach communities: St. Tropez, Carmel, Monterey, Bar Harbor, Key West, Nassau, Palm Beach, and Newport. The houses were two-, three-, and four-bedroom designs. (RNA.)

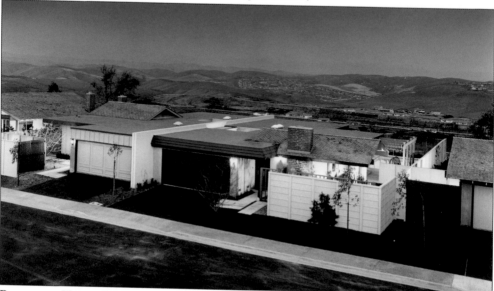

PANORAMIC VIEWS, CROWN VALLEY HIGHLANDS, 1969. The architectural design included several refinements of the new and popular garden home concept of total lot use coupled with a total streetscape design and development. (RNA.)

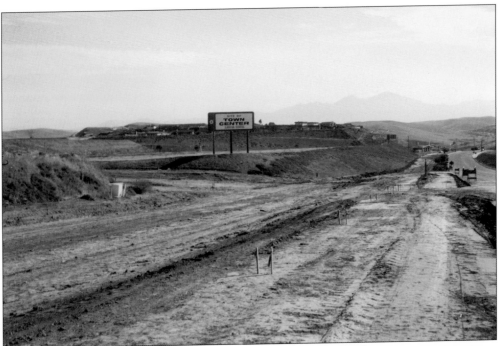

LAGUNA NIGUEL TOWN CENTER, AUGUST 1967. By 1966, the original town center concept was to move ahead with the goal that it become the hub of activity in Laguna Niguel. (OCA.)

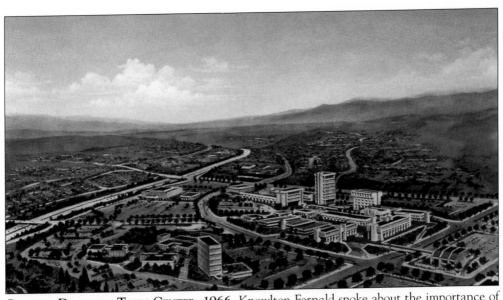

CONCEPT DRAWING, TOWN CENTER, 1966. Knowlton Fernald spoke about the importance of the town center and civic center: "One of the most important requirements of Laguna Niguel Corporation . . . was the preparation of a master development plan. This plan is an outstanding plan. In addition to locating building, parking, and pedestrian areas on the property, it specifies a theme for architectural and landscape character. The residents of Laguna Niguel, the County of Orange, and we in Laguna Niguel Corporation can be justly proud." (RNA.)

SITE FOR COURTHOUSE AND FIRE STATION, 1966. Laguna Niguel Corporation deeded 25 acres to the County of Orange in 1966 for the purpose of constructing a county civic center complex. (KFA and DPHS.)

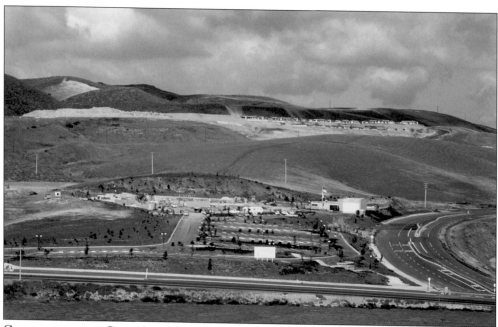

CONSTRUCTION OF CIVIC CENTER COMPLEX, 1968. Orange County studies in the mid-1960s "proved Laguna Niguel will be a population hub of the South Coast region." In the early revised master plan, the civic center and adjacent town center were identified as "the business-cultural fulcrum of the community." (KFA and DPHS.)

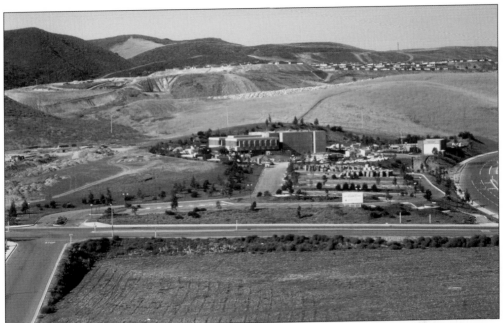

CIVIC CENTER COMPLEX AND FIRE STATION, 1970. As Knowlton Fernald stated at the opening ceremony, "The decision of the County of Orange to locate this important facility in The Laguna Niguel Town Center area is particularly significant as an indication of the importance of this location in the years to come." (KFA and DPHS.)

FIRE STATION, CIVIC AND TOWN CENTER, JUNE 1968. The first fire station in Laguna Niguel was dedicated on the county site. At the ceremony, Knowlton Fernald said the "Laguna Niguel Town Center area will develop as an important center, not only for government but also for business and professional uses, commercial uses, and cultural and entertainment uses of regional significance." (KFA and DPHS.)

SOUTH COUNTY REGIONAL CIVIC CENTER, 1970. The architectural design of this building was based on some of the original modernist aesthetic designs planned for Laguna Niguel in the early 1960s. As in the community renderings of shopping areas, offices, mid- and high-rise housing, and hotels, this style of design was noted by architectural critic Reynar Banham "not as a style but as the expression of an atmosphere among architects of moral seriousness." (KFA and DPHS.)

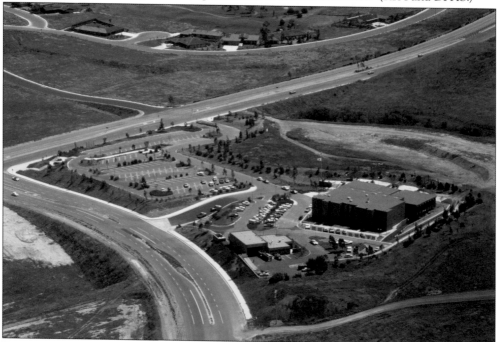

FIRE STATION AND COURTHOUSE, 1970. A branch of the Orange County Public Library was later built on this site. At the corner of the site where Crown Valley Parkway and Alicia Parkway intersect, the Laguna Niguel City Hall would be built 22 years after the 1989 incorporation of the city. (KFA and DPHS.)

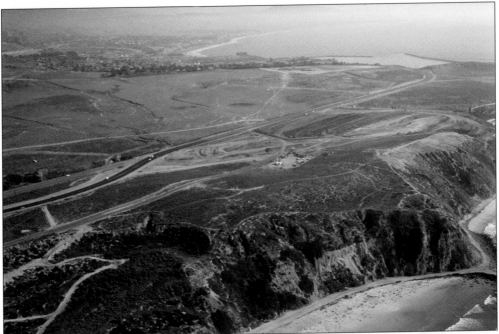

CAPRON PROPERTY FOR NIGUEL SHORES, 1966. In 1965, Laguna Niguel Corporation purchased 865 acres of additional undeveloped land and another mile of beach frontage adjacent to the southwestern border of Laguna Niguel along Salt Creek Beach. The land was the last privately owned, undeveloped beach frontage of this large size in Orange County. (KFA and DPHS.)

SALT CREEK BEACH, FUTURE ACCESS, 1967. Pedestrian and bicycle access to Salt Creek Beach in a tunnel underneath Coast Highway was originally planned in 1959. In the mid-1960s, a unique plan for the Niguel Shores coastal property was proposed that included a large saltwater lake in this creek area. (KFA and DPHS.)

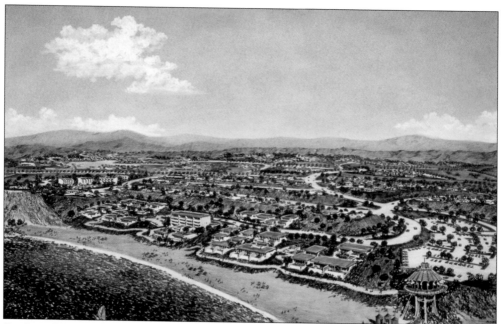

SEA LAKE VILLAGE RENDERING, 1968. This southern portion of current Niguel Shores was planned for a variety of housing types and easy beachfront access for residents. (RNA.)

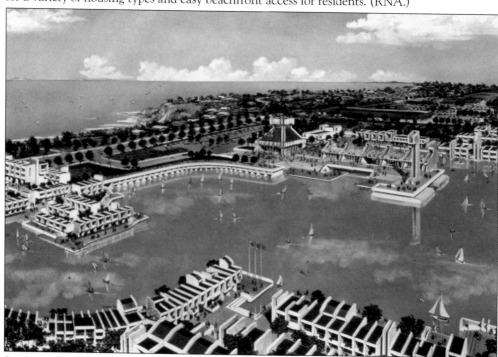

SEA LAKE VILLAGE, SALTWATER LAKE RENDERING, 1968. A 35-acre lake was designed in the canyon and creek area east of Crown Valley Parkway and south of Camino del Avion. Jacques Cousteau and his son Philippe-Pierre Cousteau were consultants for this environmentally unique design of a saltwater sea within the raised bluff at the oceanfront portion of Laguna Niguel. This water feature was not constructed. In 1983, Monarch Beach Golf Links public course opened. (RNA.)

INSTALLATION OF TUNNELS, FEBRUARY 1969. At this location under Coast Highway, and at other areas in the steep canyons of Laguna Niguel, large corrugated-tube tunnels were installed to provide pedestrian and bicycle access in the community while also allowing water to flow through the narrow valleys during rains. (KFA and DPHS.)

COAST HIGHWAY GRADING AND PAVING, NOVEMBER 1969. The highway was regraded, as were the adjacent properties, to level the street arrangements within Niguel Shores. Development here was stalled from 1971 until 1975 because grading and some construction on the site by Avco Community Developers had not yet gained full approval by the South Coast Regional Coastal Commission. (KFA and DPHS.)

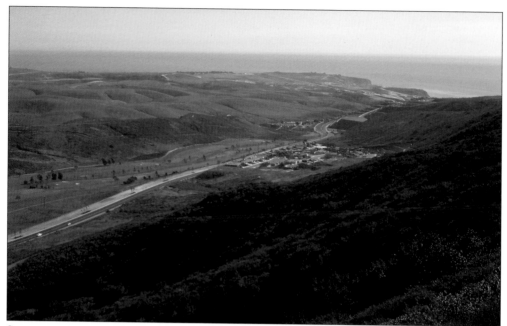

SOUTHEASTERN LAGUNA NIGUEL AND NIGUEL SHORES, FEBRUARY 1969. From Pacific Island Village, panoramic views overlook Laguna Niguel and the Pacific Ocean. Planning and approvals began in 1979 for the Ritz Carlton Laguna Niguel, at the oceanfront bluff to the right. (KFA and DPHS.)

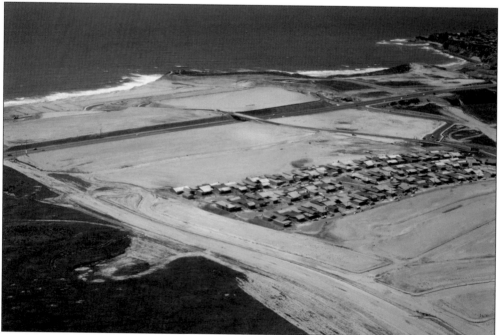

NIGUEL SHORES GRADING AND BUILDING. On March 24, 1970, a subdivision report was filed by Broadmoor Homes to start the earliest neighborhood in Niguel Shores as part of the community development by Laguna Niguel Corporation. In 1972, the construction of the Niguel Shores Recreation Center began. (KFA and DPHS.)

LAGUNA NIGUEL INLAND VIEWS, FEBRUARY 1969. Discussions within Laguna Niguel Corporation started in 1969 related to options of selling all of the more than 8,100 acres within the boundaries. Beginning in 1971, the master-planning and development entity for all of Laguna Niguel was Avco Community Developers, which acquired the land and was now responsible for the entire planned community. (KFA.)

LAGUNA NIGUEL DISPLAY, MAY 1969. Laguna Niguel Corporation had a display of the community, including photographs, maps, and brochures, at South Coast Plaza in Costa Mesa as part of a presentation throughout the mall by the Orange County chapter of the American Institute of Architects. (KFA and DPHS.)

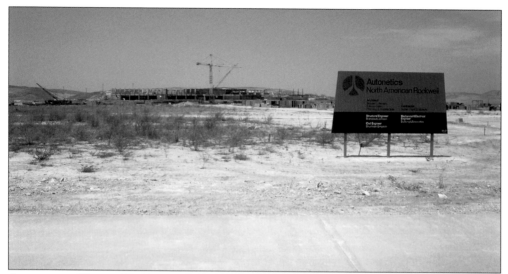

AUTONETICS, NORTH AMERICAN ROCKWELL, 1969. North American Rockwell acquired 693 acres on January 23, 1968, and began grading the site on May 13 for its new Autonetics headquarters. This project greatly changed the adjacent design for housing, which was originally planned as Niguel Ranchos, estate lots of at least one acre. As noted by Victor Gruen, "the loss of the 'estate lot' was considered to be detrimental to Laguna Niguel's goal of maintaining a full range of dwelling types, native slope character, and integral part of the overall environmental concept." (DPHS.)

WILLIAM PEREIRA RANCH OFFICES, 1968. By the fall of 1967, North American Rockwell had decided on locating in Laguna Niguel. Architect William Pereira built a ranch-style office for his team within Laguna Niguel on a hilltop overlooking the Rockwell site. Pereira's main office was on the Irvine Ranch, for which he was also the master planner. (DPHS.)

$24-Million Construction, 1969. William Pereira's firm conducted a year-long study that considered 12 major land holdings in three Southern California counties before the selection was made for Laguna Niguel. For the Autonetics facility, half the acreage was purchased from the Moulton Ranch and half from Laguna Niguel Corporation. (DPHS.)

"Ancient Babylonian Temple Tower," 1970. The exterior is pre-cast, textured concrete in a deep golden color, with plaster soffits and deeply gray tinted windows. In the spring of 1971, North American Rockwell completed the main office facility on a 92-acre portion of the site, but due to cutbacks in the industry, the approximately one-million-square-foot facility was never occupied. (KFA.)

ZIGGURAT AND ALISO WOOD CANYONS WILDERNESS PARK, 1970. Rockwell approached the federal General Service Administration (GSA) in 1971 to see if it would be interested in purchasing the facility. Ultimately, the GSA acquired the facility, including 58 acres of parking for 6,200 cars, through an exchange with Rockwell of surplus government-owned property elsewhere. (KFA.)

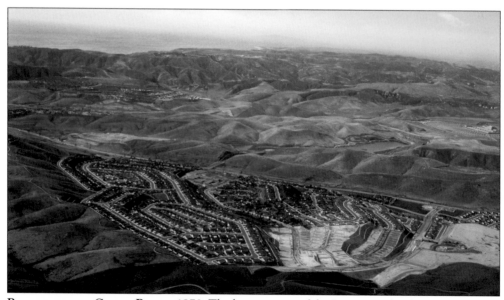

PACESETTER AND CROWN ROYAL, 1970. The later portion of the Pacesetter development was built from 1966 through 1972 around Crown Elementary School and La Plata Park, east of Crown Valley Parkway and south of Street of the Golden Lantern. A small section of the Crown Point Homes, at lower far right, was planned to contain 240 houses starting in 1965. (KFA.)

CROWN VALLEY PARKWAY AND SAN DIEGO FREEWAY, 1970. Construction of these overpasses started in 1966, but the project involved much work and coordination with the connection of Crown Valley Parkway into Mission Viejo. Additional freeway ramps were constructed in 1970. (KFA.)

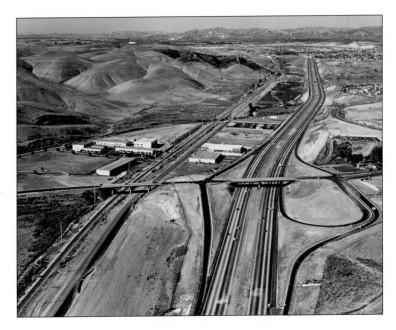

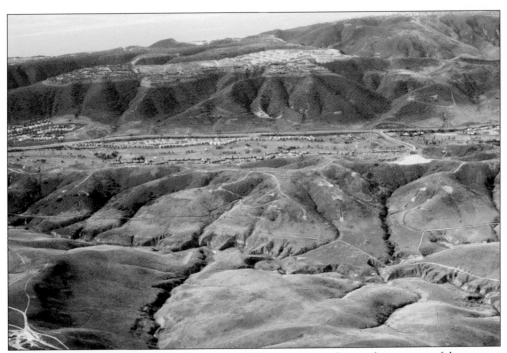

EL NIGUEL COUNTRY CLUB, 1972. This view looking west was taken at the opening of the present clubhouse, now at the renamed first tee. The two custom model homes at the right of Clubhouse Drive were the original clubhouse structures at the renamed 10th tee. Along the south fairways are condos and townhouses, West Nine and East Nine. On the hilltop far above the course, construction along Pacific Island Drive continued. (KFA.)

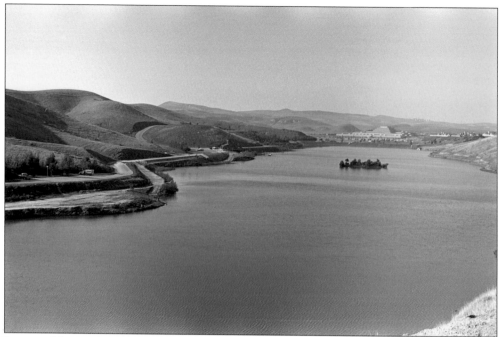

LAGUNA NIGUEL REGIONAL PARK, 1975. Laguna Niguel Lake was created in 1966 when the Sulphur Creek Dam was built. The 44-acre lake is over half a mile long and 190 feet above sea level. The lake was created for recreational purposes such as boating, fishing, and swimming, and also as a flood control facility. (OCA.)

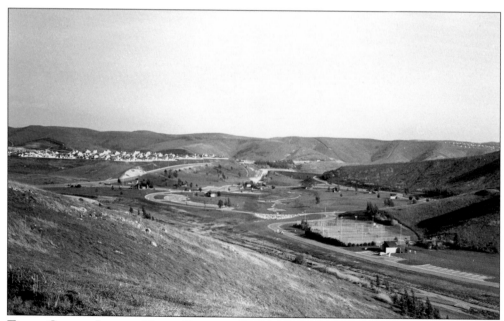

TENNIS COURTS, LAGUNA NIGUEL REGIONAL PARK, 1975. The terrain in this valley is naturally more level than any other valley in the community. The park connects to the Laguna Niguel Community Park and Aliso Wood Canyons Wilderness Park. (OCA.)

LAGUNA NIGUEL GIRL SCOUTS, 1975. A weekend event for Girl Scouts throughout Orange County was held at Laguna Niguel Regional Park. Over 1,000 Scouts attended, assembled tents, and created large art objects celebrating their history. (OCA)

THE FOOTHILLS NORTH, 1978. Avco Community Developers, starting in 1971, maintained a modern consistency for developers within Laguna Niguel in neighborhoods such as El Niguel Heights, East Nine, The Foothills, Westgreen, Greens East, Lake Park, Laguna Woods (by architect Chris Abel), Monarch Summit, Niguel Shores, Niguel Woods, Park Niguel, Rolling Hills, and West Nine. In May 1982, Avco left the home-building market and began removing the firm from the ownership of the master-planned community. (DWC.)

LAGUNA NIGUEL FAMILY YMCA, 1986. In Crown Valley Community Park, work on the YMCA started in 1984 and the facility opened in 1986. The YMCA facility was built next to the Crown Valley Community Park building and pool. (Author's Collection)

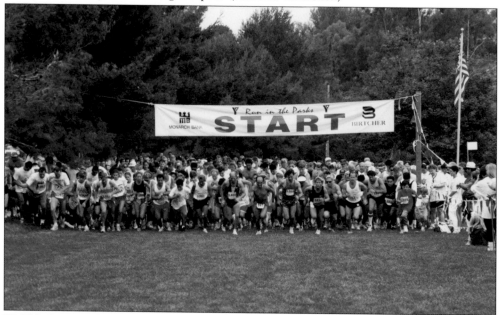

YMCA ANNUAL RUN IN THE PARKS, 1978. Each Fourth of July, the Crown Valley Community Park and Laguna Niguel Regional Park host a 5K run and walk, 10k run, dog walk, and children's races. (Laguna Niguel YMCA.)

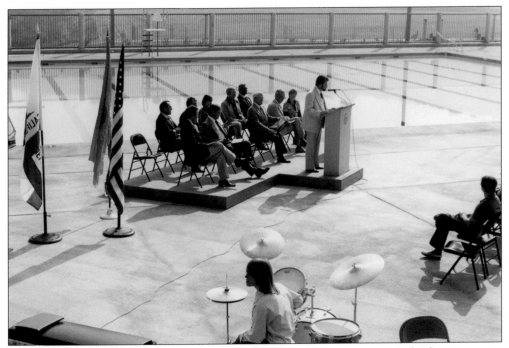

CROWN VALLEY COMMUNITY PARK, NOVEMBER 1978. The dedication ceremony for the community park building and pool was led by Dennis Devine, the committee chairman. Pastor Ray Farness of the Mission Lutheran Church provided the invocation and benediction. Orange County supervisor Thomas F. Riley was a speaker. (MLCA.)

AVCO MOVES A STRUCTURE, 1980. Avco Community Developers donated one of its structures to Mission Lutheran Church. The building was moved four miles inland along Crown Valley to La Paz Road. (MLCA.)

MISSION LUTHERAN CHURCH CONSTRUCTION, 1980. The building at right was donated to the church by Avco Community Developers and moved inland from the Laguna Niguel coastline. On the site, a construction crew is building the church structure of wood and concrete. (MLCA.)

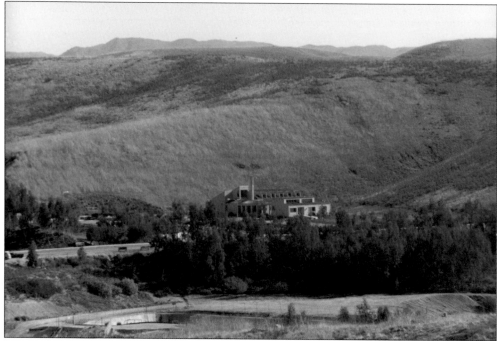

MISSION LUTHERAN CHURCH, 1980. The site for the church is at the corner of La Paz and Yosemite Roads on a hill overlooking Lake Laguna Niguel at the Regional Park. A large stained-glass window in the church was made by Judson Studios, established in 1897 and the oldest family-run stained-glass studio in America. (MLCA.)

ICE BLOCKING AT COMMUNITY PARK, 1980. The first ice blocking festivities in Laguna Niguel were at the Laguna Niguel Community Park. Outdoor activities for children were an important part of the planned community at parks, hillsides, valleys, lakes, and the beach. (MLCA.)

COMMUNITY PARK AMPHITHEATER, 1981. Outdoor entertainment during the day and in the evening under the stars is about social gathering and linking the community within public spaces. Behind the amphitheater, the 18-acre Niguel Botanical Preserve was later created with over 2,000 plant species and is connected with 34 miles of walking trails. (MLCA.)

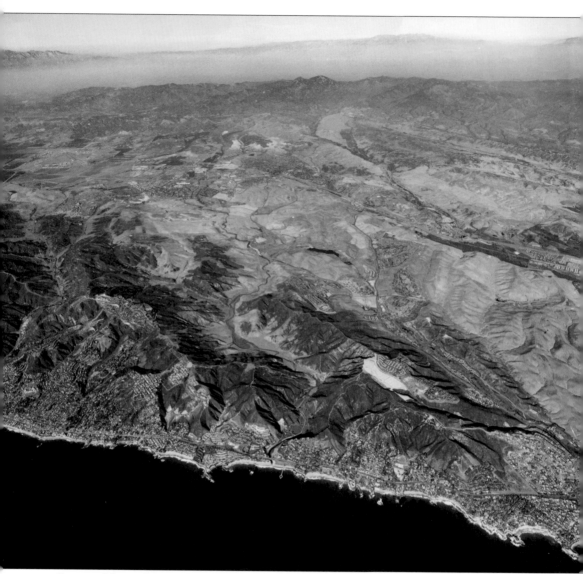

LAGUNA NIGUEL INLAND VIEW, OCTOBER 1975. The community is at the right, from the coastline and through the narrow valley. The land within a planned community is the key component of history and use. Laguna Niguel's most vital asset is its master plan, which foretells the size, form, and character of the community. While many housing developments in the mid-20th century were simply known as "suburban bedrooms," the early planning of Laguna Niguel, noted as a "new town," was built on the philosophy that families who make up a community should have most of their economic needs and social and cultural interests satisfied by facilities within the community. As noted in the Laguna Niguel feature in *House & Garden* magazine in August 1964, "Churches, commercial, residential, recreation and industrial areas are as important to a sound master plan as private houses." (OCA, Wayne Curl Collection.)

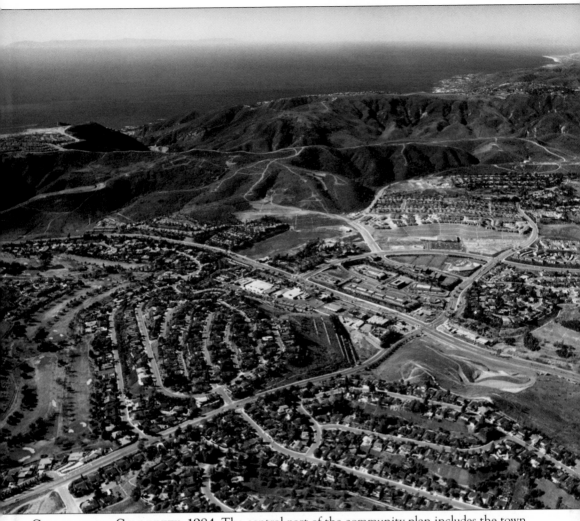

CENTER OF THE COMMUNITY, 1984. The central part of the community plan includes the town center and civic center, which were part of the original 1959 master plan. From 1959 through the mid-1980s, high standards of design were enforced in the community. The goal was to ensure a cohesive and aesthetically appealing environment. High and middle-high income groups were positioned to generally overlook a lake or golf course or have an ocean or mountain view. Middle income areas were also enhanced by adjacent high-quality residences, and the entire neighborhood was to be enriched by the change in scenery and varying character. In the Laguna Niguel project, where development was planned to take place over 10 or more years, the seven general neighborhoods were planned to be built with a full range of residences, including multi-family complexes; single-family small, medium, and large houses; and estate lots. As Victor Gruen stated: "A neighborhood with the same quality throughout would appreciably slow down the development pace by catering to only a portion of the residential market potential." (LLA.)

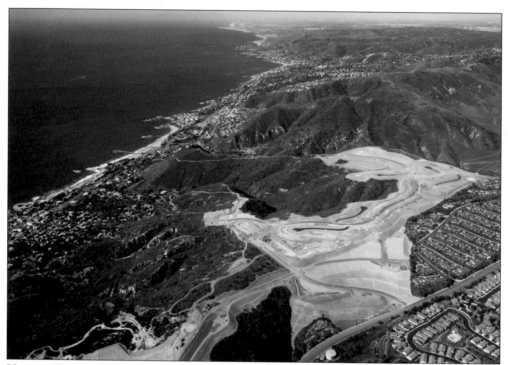

VIZCAYA, LAGUNA SUR, MONARCH POINT ESTATES, AND MONARCH POINT, JANUARY 1985. Most of the lots in the initial phases of development throughout Laguna Niguel from 1959 to 1982 are stepped down the hillside on single-loaded streets, providing unobstructed views. As explained by Ricardo Nicol, the original Laguna Niguel Corporation architect, the best homesites on hills are laid out in a series of terraces designed to preserve the natural beauty of the hills. But when individual developers obtained land after the master developer left the community, many undeveloped sites were heavily graded into level sites that actually disrupted views for each lot. The original master plan approached building according to the present and future needs of people in Laguna Niguel, but many of the developers after 1982 did not achieve that. (LLA.)

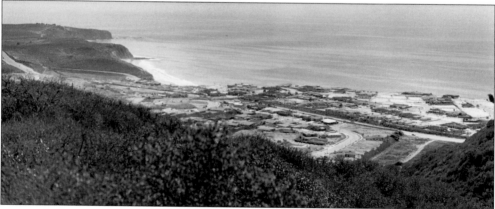

VIEW FROM NIGUEL HILL. The highest peak within Laguna Niguel still offers superb 360-degree coastal and inland views from houses, public parks, and hiking trails. In the earliest 1960 advertisement for lots and houses in Laguna Niguel, the development was called "The Ultimate Community," featuring "Clean azure skies, sparkling blue ocean and gently rolling hills are the perfect setting for this 7,000 acre master-planned community." (KFA and DPHS.)

SEA COUNTRY, LAGUNA NIGUEL, 1972. This logo, in blue and green, and the logotype for the community were created when Avco Community Developers acquired the property. All of the entrance and neighborhood signs within the community were modified to be consistent with the graphic design to visually link the community throughout the entire site. (KFA.)

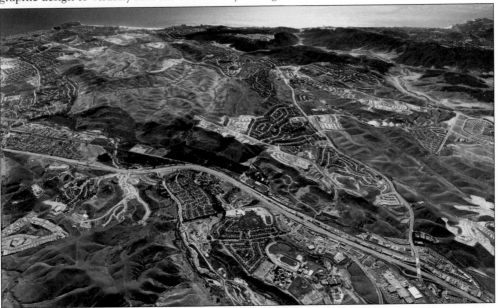

"NATURE AND MAN COOPERATE" LAGUNA NIGUEL, SEPTEMBER 1981. The entire community is in this aerial photograph. At lower right, Crown Valley Parkway connects to the San Diego Freeway, and the parkway continues upward, through the middle of the community, linking to the white-sand beach at the coastline. In May 1963, Laguna Niguel was described by Laguna Niguel Corporation as "where Nature and Man cooperate to create a fabulous masterplan of coast and country living. . . . Laguna Niguel is a masterplan which gloriously fulfills the promise and potential of what California life in Orange County can be." (OCA, Robert R. Hosmer Collection.)

DISCOVER THOUSANDS OF LOCAL HISTORY BOOKS
FEATURING MILLIONS OF VINTAGE IMAGES

Arcadia Publishing, the leading local history publisher in the United States, is committed to making history accessible and meaningful through publishing books that celebrate and preserve the heritage of America's people and places.

Find more books like this at
www.arcadiapublishing.com

Search for your hometown history, your old stomping grounds, and even your favorite sports team.

Consistent with our mission to preserve history on a local level, this book was printed in South Carolina on American-made paper and manufactured entirely in the United States. Products carrying the accredited Forest Stewardship Council (FSC) label are printed on 100 percent FSC-certified paper.

MADE IN THE USA